DIGITAL MANGA WORKSHOP

D0258520

DIGITAL MANGA
WORKSHOP

ILEX

JARED HODGES AND
LINDSAY CIBOS

CONTENTS

First published in the United Kingdom in 2005 by

ILEX

3 St Andrews Place
Lewes
East Sussex BN7 1UP

ILEX is an imprint of The Ilex Press Ltd
Visit us on the web at: www.ilex-press.com

Copyright © 2005 The Ilex Press Limited

ILEX Editorial, Lewes:
Publisher: Alastair Campbell
Executive Publisher: Sophie Collins
Creative Director: Peter Bridgewater
Managing Editor: Tom Mugridge
Editor: Kylie Johnston
Art Director: Tony Seddon
Junior Designer: Jane Waterhouse
Designer: compoundEye

ILEX Research, Cambridge:
Commissioning Editors: Alan Buckingham
Development Art Director: Graham Davis
Technical Art Editor: Nicholas Rowland

Any copy of this book issued by the publisher as a
paperback is sold subject to the condition that it shall
not by way of trade or otherwise be lent, resold, hired
out, or otherwise circulated without the publisher's
prior consent in any form of binding or cover other
than that in which it is published and without a similar
condition including these words being imposed on a
subsequent purchaser.

British Library Cataloguing-in-Publication Data
A catalogue record for this book is available from
the British Library.

ISBN 1-904705-46-4

All rights reserved. No part of this publication may
be reproduced or used in any form, or by any
means – graphic, electronic, or mechanical, including
photocopying, recording, or information storage-and-
retrieval systems – without the prior permission of
the publisher.

Printed and bound in China

For more information on this title please visit:
www.web-linked.com/manguk

INTRODUCTION

Welcome to *Digital Manga Workshop*, the guide that introduces you to the exciting world of digital manga-style art. In the pages of this book you will find a wealth of information on everything you need to know, from the kind of tools you need, to scanning your image, to colouring techniques and special effects. All the basics are covered – and then some! Whether you are a beginner to the art of manga, or more advanced, you will find hints, tips, and techniques to help you create great manga-style digital art. But first, a few introductory points to get you started.

WHAT IS DIGITAL ART?

Digital art is a broad-ranging term that refers to any type of artwork that has been created with the use of a computer. From a rough image put together in Windows Paint, or a manipulated and edited photo in Adobe Photoshop, to a digital painting in Corel Painter, or a three-dimensional figure in Bryce 3D – all are examples of digital art.

WHAT IS THIS BOOK ABOUT?

This book deals with the digital techniques required for creating manga-style digital art. Most of the techniques involve the use of the industry-standard programs: Adobe Photoshop and Corel Painter. From scanning, clean-up, and saving, to inking, colouring, special effects, and more, this guide will help give you a basic foundation in digital artwork.

WHO IS THIS BOOK INTENDED FOR?

This book is aimed at the artist who has at least some confidence in his or her drawing ability, and who is interested in either learning how to extend their artwork into the digital realm, or how to improve and expand upon their existing knowledge. These artists should find this book helpful and insightful.

HOW MANY PEOPLE ARE INVOLVED IN THE CREATION OF AN IMAGE?

In contrast to American comic artwork, or animation studio work (where many artists work together to bring a project to fruition), manga-style image-creation is generally the creation of a single artist, who must be skilled in all aspects of the process – which includes everything from initial composition to the pencil work, inking, colouring, and any special effects.

WHAT BASIC SKILLS IS IT IMPORTANT TO HAVE?

First and foremost, line work is important. The better you are at drawing, the better your overall image will turn out. Painting is another helpful discipline. The more you know about traditional art and artistic method, the better. A good, solid foundation in the elements of art (colour, value, line, shape, form, texture, and space) and principles of art (balance, contrast, proportion, pattern, rhythm, emphasis, unity, and variety) will help your images along immensely.

HOW CAN I GET THE MOST OUT OF THIS BOOK?

The most important thing to keep in mind as you work through this book is that, while reading the book is beneficial, the most benefit will come from actively practising the instructions as you read. Experiment with the techniques and you will learn from them.

We recommend that you read through the entire book at least once or twice before you try out any of the techniques. This will enable you to soak up the information first and then apply the techniques to your own image-creation. Remember, your success is measured by the amount of effort you put into the learning.

WHAT SUPPLIES DO YOU NEED TO CREATE DIGITAL ART?

Since this is a book on digital art, owning a computer and a computer graphics program of some sort is a definite must! You'll find some comprehensive suggestions on software, hardware, and other supplies you'll need in the first chapter. Photoshop and/or Painter users will be able to get the most out of this book, but it will still provide valuable insights for users of other art-creation programs, and even those working in traditional media.

AND FINALLY...

It is our hope that you find this book informative, useful, and fun. Throughout, we offer tips, suggestions, and step-by-step guides that you can use when creating your own artwork. Please keep in mind that the methods presented in this guide are not the only methods you might employ in creating digital artwork. The methods we share in this book have evolved over years of trying out techniques and refining them. But, just as there are numerous ways to approach drawing, so are there numerous ways to create digital art. Once you've learned the basics, don't be afraid to experiment with other tools and techniques to find your own personal style. Most importantly, do have fun with it!

Good luck with your digital art, and remember that, with practice and dedication, you'll continue to grow as an artist.

Lindsay Cibos and Jared Hodges

1

TOOLS OF THE TRADE

If you're serious about digital art and/or you're considering becoming a professional in the field, make it a point to purchase the best supplies you can afford. Investing a lot in the beginning can save you money and the hassle of upgrading later on. Some tools and supplies can be very expensive, but the effects they'll have on your artwork make it worth it.

Good tools, if used correctly, can help enhance your artwork, and allow you to give your art a professional shine. After all, how many digital masterpieces have you seen that were created in Windows Paint? However, always keep in mind that buying the best tools alone won't make you a great artist – you'll still have to work hard and practise to become better. It's the tools and skills together that will allow you to create beautiful works of art.

Purchasing good tools can also force you to be serious about your chosen profession (in other words, 'I went out and spent all this money on equipment – I can't give up now!').

If you're unsure of how serious you are, you might want to start off with the more affordable tools noted in this chapter (for example, a smaller Wacom tablet, or an earlier version of Photoshop). It may not be the best equipment, but it'll suit you well enough for the purpose of experimentation and practice. You can always upgrade your equipment if you decide to become more serious later on. Do keep in mind that this could end up costing you

DIGITAL VERSUS TRADITIONAL ART

Why digital art? Over the years, computers have evolved into tools for a vast range of different uses, including artwork-creation and editing. They are capable of producing imagery that looks just as good as traditional-style artwork and maybe even better. Add to that its inherent flexibility and you've got a good reason to make the leap to digital.

ADVANTAGES OF DOING ARTWORK ON THE COMPUTER

- Flexibility and functionality
- Smaller workspace
- Variety of styles and possible techniques
- No brushes to wash or paint to clean up afterward
- The 'undo' button
- High resolution and unlimited paper size
- Multiple saves allow for room to experiment
- Almost every art tool you could possibly want is bundled

Isn't it expensive?

Of course, computer hardware and software can easily cost you anywhere from £50 to £3,000 or more in start-up costs, depending on what you already have. It's a lot of money to invest, but you'll only have to buy your supplies once (until you upgrade, of course), and your digital paint will never run out or dry up.

Traditional art can also be expensive. You'll have to continuously buy new supplies (including pencils, pens, paper, paint, etc.) as old ones run out, which can accumulate into a considerable amount of money. And consider supplies like oil paint: one small tube can cost more than £10. Throw in about ten more tubes of paint,

a canvas, brushes, and other miscellaneous extras, and you've practically spent what Photoshop or Painter would cost you.

Does digital art take longer?

It's true that good digital art can take a good deal of time to produce. But this is true of all good artwork, regardless of the medium.

Both digital and traditional media have their advantages over the other (e.g. you will never have to wait for a digital image to dry, but you will have to wait while your computer saves it). As with all artwork, the more detail you put into it, the longer it's going to take. The more experienced you are with a medium, the less time your project will take to complete.

In other words, digital art really doesn't take longer than traditional artwork. Both take an amount of time proportional to the amount of detail and effort you put into your work.

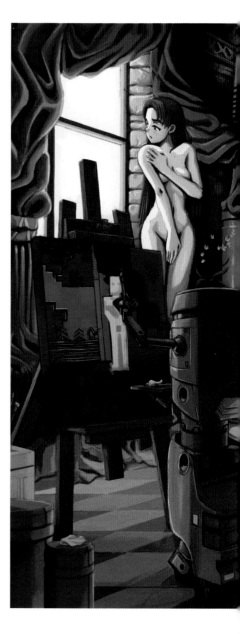

▶ As the robot painting the live model demonstrates, the line between digital and traditional artwork is becoming ever more blurred today.

THE PROS AND CONS

	DIGITAL	TRADITIONAL
COST	**Pro:** You'll only have to buy your graphics software once. Included in the software is an unlimited supply of brushes, pens, and other tools of all kinds at no extra cost to you. **Con:** The software can cost up to several hundred pounds.	**Pro:** Supplies can be very affordable. **Con:** Good, professional-quality art supplies can be quite costly. For example, a good sable paintbrush can cost £20.
REPLACEMENT PARTS	**Pro:** No supplies to replace or clean. Your graphics software will always run **Con:** But for the newest and most functional tools, you might want to occasionally upgrade.	**Con:** You'll need to buy replacement parts constantly. Brushes will fall apart, nibs will break and rust, ink will dry out. All consumable art supplies (pens, pencils, paper, ink, paint, etc.) will eventually run out, and new ones will need to be purchased.
SPEED	**Pro:** Corrections and adjustments can be made quickly using an array of tools included with the software. **Con:** Opening and saving files is often time-consuming. Higher resolution and larger image size means more picture to complete.	**Pro:** Smaller image size means less picture to complete. **Con:** Paint takes time to dry, and placing a hand in wet paint will smear and ruin your picture.
SETUP	**Pro:** Just turn on your computer and you're ready to work. **Con:** You must be at a computer to work. Unless you have a laptop, your workstation is pretty much stationary.	**Pro:** Art can be done anywhere: at home, school, work, etc. **Con:** Supplies need to be gathered and media need to be prepared before you can start working.
LEARNING CURVE	**Pro:** Practising with a tool doesn't waste costly supplies, and mistakes can be easily undone. **Con:** It's a whole new way of doing artwork, and there are lots of tools to become comfortable with. Very complex, can be overwhelming.	**Pro:** If you know how to use a pencil, you're already a step in the right direction. **Con:** Some tools have a steep learning curve, and are difficult to use correctly without a significant amount of practice.
MISTAKES	**Pro:** Mistake? Just hit 'undo'! Smudges and ink blobs will never accidentally happen. **Con:** Computer programs will crash on occasion, causing you to lose hours of work, or even possibly your entire picture.	**Pro:** Rubbers and Tippex can fix some mistakes. **Con:** Mistakes can ruin a picture, and there are no 'undo' or 'save' buttons. Smudges and droplets of ink are common disasters, and they happen to even the most skilled artists. Tippex doesn't fix everything, and can even cause problems of its own.
CLEAN-UP	**Pro:** Just save and close the program and you're finished! **Con:** Files must be occasionally backed up and sorted through.	**Con:** Clean-up can be a hassle; brushes and pens must be washed after every session.

INTRODUCTION TO COMPUTER HARDWARE

Think of the computer and the accompanying equipment as your art environment. The various peripheral tools plugged into your computer as well as the programs installed on your computer make up this environment. This section looks at the hardware you need to get started.

Your computer and its peripheral devices and software are required for the creation of digital artwork. It's important to know and understand how any tool functions before using it. If the tool was a paintbrush, it would be important to know how to hold it properly, what types of media it was designed for, the brand name, bristle length, and so on. It's also important to keep your tools clean and in working order. All of these practices carry over to your computer.

What computer software and hardware do you need to get the most out of your digital art? That's dependent on what you want to get out of your images and how much you're looking to spend. A workaround for artists with slower computers is to break up your working files into separate parts – one for character art, one for background art, etc. But if you can afford it, do yourself a favour and upgrade. You'll save yourself a lot of hassle and frustration in the long run.

The following list of computer components will help you select the most appropriate system for your needs.

THE HARDWARE

Computer
There are a lot of different devices packed into a computer, all serving their designated function in order to make it work. Processor power, RAM, and hard drive space will be your main concerns when choosing a good computer.

Processor
This is the brain of the computer, the part that does the number crunching. The faster the processor, the faster operations will take place. Whether you're making a stroke across your tablet, opening a program, or running a filter, the processor is the one doing the work. Aim for the best processor you can get without breaking the bank.

Graphics card
The graphics card is a mini processor, dedicated to sending a signal to your monitor. You'll want a graphics card that can put out at least 24-bit colour (16 million colours) at 1024 x 768 screen resolution, and with a refresh rate of 80 hertz or better. Matrox makes cards tailored to the needs of graphic artists, but most mid- to high-end gaming cards should do just as well.

Memory (RAM)

This stores information while you're working. Most PCs today come with 256MB of RAM in their default factory configuration. Unfortunately, the operating system alone will use up a large chunk of this, leaving very little for other programs. This is like having a desk that is so small you can only put a portion of your necessary supplies on it before it's completely full. Once it's full, you won't be able to put any more supplies on the desk until you remove others.

Simply put, more RAM allows you to work with larger, higher-resolution files in large, RAM-consuming programs like Photoshop, with less signs of slowdown. I suggest you have at least 512MB worth of RAM, but ideally a gigabyte or more.

COMPUTER PERIPHERALS

Graphics tablet and pressure-sensitive pen

A necessity for creating digital artwork, the tablet is used to draw and paint directly onto the computer. Most commonly used in conjunction with a pressure-sensitive pen (also known as the stylus), it can be used with other peripheral tools, such as the digital airbrush, or the 4D mouse.

The tablet and stylus are easily comparable to your pencil and paper – or any other art media, for that matter. Your graphics tablet is our multi-purpose applicator device. Using it along with graphics software gives you a 'Swiss Army' art tool. Depending on the program you're using and the settings you have for your tablet, it can take on the form of various pencils, pens, brushes, airbrushes, rubbers, sponges, charcoal, etc. As you drag your stylus against the surface of the tablet, it calculates the amount of pressure, tilt, and velocity in order to produce the appropriate line on-screen.

Some artists find the tablet's surface to be unnaturally slippery. If you find this to be the case, try taping a sheet of paper over the tablet's surface to simulate real paper texture.

Tablets are available in a variety of sizes, including 4 x 5in, 6 x 8in, 9 x 12in, 12 x 12in, and 12 x 18in. The two middle sizes, 6 x 8in and 9 x 12in, are the most functional. 4 x 5in is too small, 12 x 12in isn't proportional to the screen, and 12 x 18in is too large. Tablets can get very expensive, but the smaller ones are affordable, and even a small one is better than nothing at all.

Without a doubt, WACOM makes the best tablets currently available on the market. For more information, check out WACOM's website at http://www.wacom.com

Mouse

Any type of mouse will do. It's recommended for navigation, but not for digital art. The mouse was intended to point and click, not draw and colour artwork. It's possible to create artwork with a mouse, but it's tedious, difficult, lacks the pressure sensitivity of the tablet, and often yields terrible results.

Monitor

For CRTs, choose one with a low dot pitch, large on-screen viewable area, a flat screen, a resolution of 1024x768 or higher, and a minimum refresh rate of 80 hertz. 17in is good, 19in or larger is better.

If you prefer the sleekness of the LCD, and don't mind the extra expense (they tend to cost twice as much as their CRT equivalents), look for one with a native screen resolution of 1024 x 768 or higher, and a 500:1 contrast ratio or better.

Many artists prefer CRTs over LCDs because of their excellent colour clarity.

Some artists employ a dual monitor setup. A secondary display gives the artist more room to work. The benefits are trifold:

● The drawing program can be stretched across both screens to maximize drawing space
● One monitor can be utilized as a canvas, the other for tool palettes
● The second monitor can be used to display reference material

Scanner

Converts artwork into pixel data for use on the computer. Any reasonably priced flatbed scanner on the market will do. For more information, see the scanning section *(pages 34–5)*.

CD/DVD writer

Having either a CD or a DVD writer as part of your working setup will enable you to save your work off the hard disk, opening up space for everyday work, offering you temporary storage and archiving possibilities as well as providing you with a means for transporting your images. While DVDs have greater capacity than CDs, the dominant storage format is CD-R, which combines sufficient capacity, low cost, and almost universal compatibility.

Printer

If you plan on selling prints of your artwork, choose a printer that's capable of producing photographic-quality, glossy prints. We recommend the Epson 1280, which is the current standard for professional homemade prints. Otherwise, stick to an affordable ink-jet printer.

Digital camera

As you will see later in the book, having a digital camera at your disposal is a prerequisite if you want to be creative and incorporate photographic backgrounds and elements to your artwork. There are three levels of digital camera available to you: entry-level compacts, mid-range compacts that incorporate a zoom lens, and a digital SLR camera. The latter will provide you with the most professional quality and diverse options, but even a basic digital compact will offer you what you need.

INTRODUCTION TO COMPUTER SOFTWARE

As with computer hardware, you won't be able to get very far with your digital art without the appropriate computer software. There is a variety of software applications on the market of varying quality and cost.

The industry-standard programs of the artist community are Adobe Photoshop and Corel Painter, and we personally recommend both. However, beginners, hobbyists, and artists with a limited budget may find them to be cost prohibitive. Luckily, there are budget alternatives, including Paint Shop Pro, openCanvas, The GIMP, and others, as well as the option to purchase older versions of Photoshop and Painter at a reduced cost.

THE SOFTWARE

Adobe Photoshop
Well-suited for digital manga-style artwork. Despite the fact that Photoshop was created exclusively with photo-editing in mind (hence the name 'Photoshop'), it has become the application of choice for professional artists, web designers, and photo editors alike. In the creation of digital manga art, Photoshop is best utilized for cel art, airbrush, and even traditional-style colouring, as well as special effects, composition, and typesetting.

We recommend version 5.0 and above. Versions before 5.0 lack many of the key functions.

Corel Painter
Painter is also very well-suited for digital manga artwork. The software is best utilized for sketching, inking, and traditional-style colouring. There's no other application that offers such a wide variety of tools (practically any artist tool that you may have ever wanted to try: chalk, pencil, watercolour, ink, palette knife, charcoal – the list goes on and on) with such a high level of customization. Tools may be tweaked and adapted to create new tools and perform specific tasks, and all settings can be saved for future use.

We recommend Version 6.1 and above. Versions before 6.1 lack layers support and compatibility with Photoshop.

Paint Shop Pro
On basic operations and general appearance, Paint Shop Pro is similar to Photoshop. If you're working with a limited budget, it makes for a decent – albeit clunky – alternative. It's also easy to learn, but this is in part due to its failure to provide the level of features and functionality found in Photoshop.

openCanvas
This graphics application is popular within the digital manga artist community. It's similar to Painter, but costs less and runs faster. However, while it can be used for sketching, inking, and painting, it lacks the vast majority of tools available in Painter. As is the case with the rest of the programs listed above, openCanvas is able to save files as multilayered PSDs, allowing for easy

▲ Paint Shop Pro (*top*) and Open Canvas (*above*) are good software packages that are affordable enough for novices to experiment with a digital environment.

COMPARISON TABLE

Adobe Photoshop
- Good for colouring, special effects, composition, and typesetting
- Most expensive
- Most stable
- http://www.adobe.com

Corel Painter 8
- Wide variety of tools
- Capable of capturing the look and feel of traditional media
- Prone to crashes and instability
- http://www.corel.com

Paint Shop Pro 8
- Similar features to Photoshop, but far more affordable
- Lacks the full range of features and the functionality of more expensive programs
- Lacklustre interface
- http://www.jasc.com

OpenCanvas
- Similar feature to Painter, at a better price
- Lacks the majority of tools available in Painter
- Requires far less system resources than Painter
- http://www.portalgraphics.net

The GIMP
- Available online for free
- Similar to Photoshop, but lacks the full range of functionality
- Extremely user-unfriendly
- http://www.gimp.org

interaction with Photoshop. It also has a unique function called Event File that records an entire drawing session and plays it back from start to finish. Event Files can be shared with other users to teach and learn techniques. Painter has a similar but decidedly less user-friendly version of this feature.

The GIMP
Similar to Photoshop, but lacks the full range of functionality. As freely distributed, open source software, it's buggy, hard to set up, and is also missing Photoshop's professional polish and user support. On the other hand, it's hard to beat a price tag of 'free'!

ART SUPPLIES AND WORKSPACE

While this is a book about using digital techniques to produce Manga-style illustration, one shouldn't forget that the origins of good illustration start with basic techniques and resources. In this section, we look at the traditional art supplies you should have at your disposal before you get started.

TRADITIONAL SUPPLIES

Unless you intend to jump right into the digital aspect from the start with the sketching stage, you'll want to have an array of traditional art supplies at your disposal.

Pencils

Artist pencils work well for sketching, particularly the soft Bs. Mechanical pencils are wonderful for creating sharp, consistent lines which are good for final drafts.

Rubbers

Of all the rubbers you might choose from, we recommend "Magic Rub."

Lightboard

Literally, a box with a light in it. The light shines through the rough pencil art, enabling you to make a clean trace of the work, ready for inking. It comes in various sizes, so choose one that's large enough for your work (mine is 11 x 17in).

Pens

For traditionally inking your work. Choose one that is waterproof, lightfast, smudge-proof, and fade-proof. Both technical pens (Sakura Pigma Micron), brushes (Windsor & Newton series 7 sable brushes), and nibs (102 Crow Quill and the 106 Hawk Quill) are viable options. Nibs give a greater range of line width, but require a higher degree of mastery.

Rulers

A must for producing straight lines, measuring proportions, and tackling perspective. I recommend picking up a roller ruler, and a T-square at least 24in in length.

Sketchbooks

Good for conceptual work and sketches.

Paper

If you plan to digitally ink, any kind will do, as long as it has a smooth surface appropriate for pencil art. Otherwise, look for paper that works well with ink.

◄ Organize your workspace so that you have easy access to everything you need.

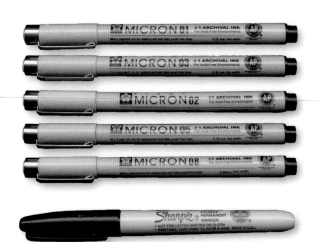

Your Wacom tablet, keyboard, and mouse should be arranged in a way that allows for easy access to all three. You'll be using the tablet for drawing, the keyboard for shortcut keys, and the mouse for quick navigation. I suggest a setup that places the tablet on the right, and keyboard and mouse on the left. I'm left-handed, so my setup is the reverse. Another option is to place the tablet in your lap, but this doesn't work so well with the larger tablets. For a more natural drawing angle, try angling the tablet off the edge of the desk or propping it up against another object.

All other tools, supplies, and reference materials you'll need for a particular session should be readily available to you (within reaching distance) and hopefully in an organized and tidy manner (or at least in a manner in which you'll be able to find them).

Finally, some artists find that having music on in the background helps them focus. Others find music too distracting, and prefer to work in silence. Also, playing music that's contextually sensitive to the subject matter of your picture may help you get into the right frame of mind – for example, listening to fast, frenetic music when working on an action scene.

WORKSPACE

Your workspace is the area where you'll spend most of your time creating art. It's important that your workspace meets several criteria: it should be familiar, comfortable, and free of distractions. A place where you can relax, but remain focused.

You'll want a good office chair that provides proper back support, and allows you to comfortably maintain good posture for long hours.

To prevent eyestrain, your computer monitor should be positioned at eye level, about 20–30in (or arm's length) in front of you.

2

DRAWING BASICS

Good drawing is the foundation of quality digital illustration. Without your drawing, you'll have nothing to build upon. If you start with a bad drawing, no amount of digital colouring can transform it into a good drawing. Only through revision and redrawing can a bad drawing be fixed. Therefore, it's important to do everything you can to improve your artwork before moving it into the digital realm.

There are countless books on the market (some quite good, some not so good) devoted to drawing, and quite a few focused on the specific topic of drawing manga-style art. This chapter does not seek to form a substitute for those books (as a single chapter could never hope to capture all the nuances of this broad topic), but rather serve as a supplemental refresher course.

With the assumption that you're already versed in a basic understanding of drawing – as well as manga-style art – this chapter touches upon specific tips that are geared towards helping you find new ways to grow and develop as an artist, and ultimately improve your artwork.

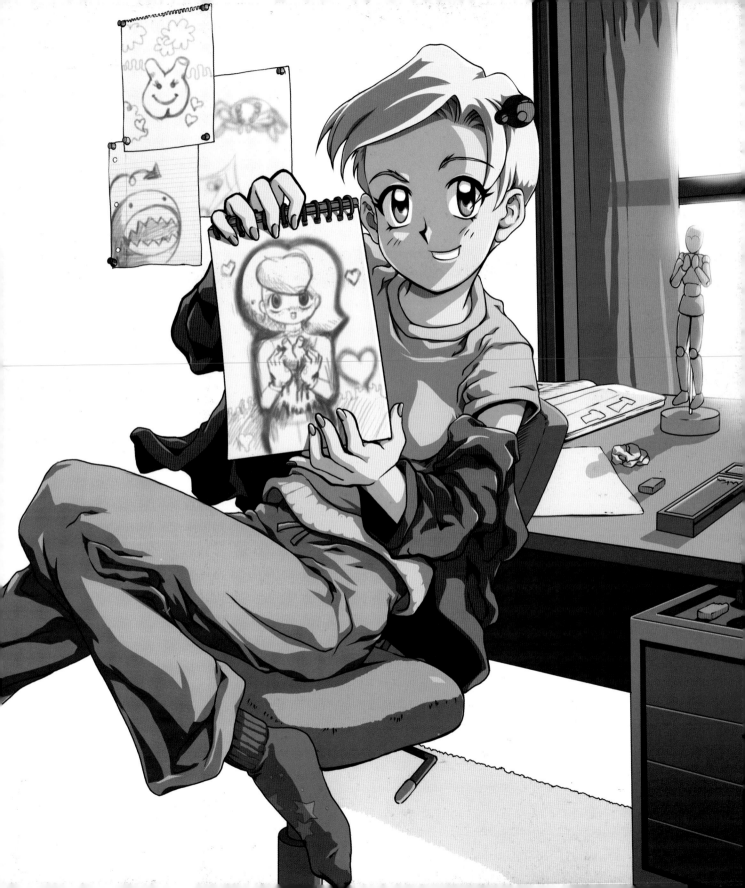

GENERAL DRAWING TIPS

A strong foundation in drawing is important for every artist. Artists often tackle difficult problems by reducing complex objects to basic forms before selectively rebuilding them. Likewise, fundamental drawing skills give artists the ability to break down and understand a subject before moving on to stylized manga characters.

PRACTICE

You're not going to become a great artist overnight. It'll take time, effort, and practice. If you're serious about improving your skill as an artist, try to spend at least an hour a day drawing. You should push yourself to produce at least one solid sketch during this period of time.

MAKE A SKETCHBOOK

A sketchbook is a place to be experimental, develop drawing skills, sketch possible concepts and compositions for pictures, and write observations, thoughts, and ideas. You can also keep magazine clippings in it. If you put a lot of regular work into your sketchbook, it can prove to be a great resource later on. When you're in need of ideas, you'll be able to return to your sketchbook for new inspiration. Get in the habit of carrying your sketchbook with you everywhere, so you'll always have it to jot down ideas.

Your sketchbook will also allow you to monitor your progress as an artist. Record dates in your sketchbook as you would in a journal to keep track of how much you've improved over a period of time.

DRAW EVERYTHING!

Observe your surroundings. Draw from life. Visit shopping centres, parks, zoos, etc., and sketch the people, buildings, landscapes, and everything you see.

Try refining the rough points in your artwork. For example, if you have difficulty with drawing hands, don't hide them behind the character's back! Focus on the hands; make them a part of the picture. Set aside time to practise drawing just the hands.

Likewise, if your figure-drawing skills are lacking, don't let your character hide in loose, baggy clothing. If you struggle with drawing clothing, practise drawing all types and textures of fabrics. Study how fabrics fold and wrinkle, and how shadows fall upon their form. Observe how clothing bends and contorts around the body.

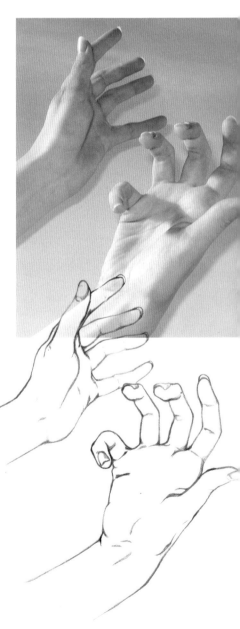

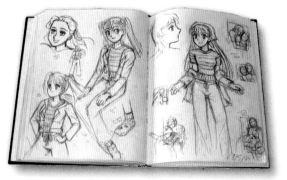

◄ Keep a book or file containing all your sketches and drawings in one handy place. This will provide you with an immediate reference for later, more complete work.

▶ In manga-style artwork, line is often stressed over other artistic fundamentals. Studying people and objects through the use of contour line drawings is a useful skill.

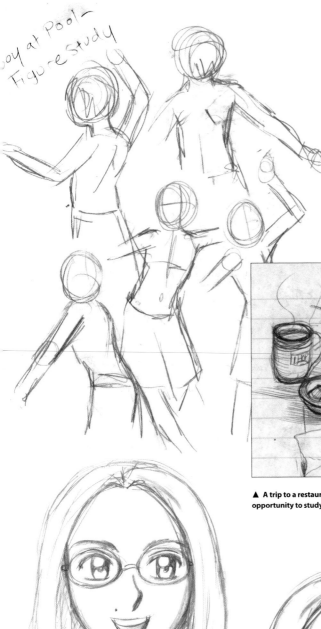

◄ Quick gesture drawings of a young boy are rough and incomplete, but capture basic movement and form. These poses and postures can later be incorporated into a more complete work.

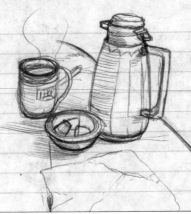

▲ A trip to a restaurant for breakfast can be an opportunity to study different objects or environments.

QUALITY CONTROL

The mirror test

To pinpoint problem areas, try viewing your drawing in reverse by holding it up to a mirror, or shining a light through it. This fresh look at the drawing helps previously undetected mistakes to pop out.

Second look

When you feel that your drawing is complete, stand back and look at it with a critical eye. Get your friends and family (preferably ones who will be truthful with you) to look it over and tell you what they think are the picture's strengths and weaknesses. Take the time to correct any problem areas. Over time, this re-examination of your artwork will greatly improve your drawing skills. You'll learn more from your mistakes and avoid making the same mistakes on your next picture.

ART CLASSES

I strongly recommend taking any available art classes you can. They can teach the many important fundamentals of art, such as the visual elements (line, shape, mass, texture, light, colour, and space), and the principles of design (balance, emphasis, scale, proportion, repetition) and more. Many teachers disapprove of manga-style artwork, but don't let that discourage you from learning other aspects of art, especially since a prerequisite to creating good manga art is a strong understanding of the fundamentals.

▲► Flipping this drawing reveals a previously undetected lopsidedness, as well as other minor problems.

MANGA DRAWING TIPS

Your character's face is going to be a primary focal point in your manga-style artwork, so attention to proportion and detail is paramount! You will use these basic guidelines for producing manga-style faces and features again and again, so it is worth getting the fundamentals right from the beginning.

DRAWING THE FACE

When you are drawing your manga-style character's face, every element – from the shape of the eyes and the size and spacing between features, to the sharpness of the chin or the height of the cheekbones – is important and must be considered with care. If anything is out of alignment or improperly spaced, the viewer may sense that something is wrong with the picture (even if they can't tell what). In this section, we'll be discussing general proportions that are true for both realistic and manga-style characters, as well as manga-specific pointers.

Keep in mind that there is a whole range of styles in manga-style art, from gritty and realistic to hyper-cute. There's no single correct way to drawing the face, eyes, hair, nose, and so on. But if you follow the basic proportions, you'll be able to make your characters more three-dimensional and believable, regardless of your style.

HEAD

This step-by-step example only shows the head drawn from the front, but with a good understanding of the positioning between facial features, and a lot of practice, you'll be able to draw the head from any angle. Try looking in the mirror if you're stumped: the human face differs greatly from a manga-style face, but the basic positioning between facial features remains the same.

1 *To build up the face, start by sketching a circle with intersecting vertical and horizontal lines to indicate the direction the character is looking.*

2 *To draw the jaw, start from the end points of the horizontal line, and draw a line that slightly curves outwards to indicate the cheeks, and then slopes inwards to form the chin. Make sure the vertical line intersects with the centre of the chin.*

3 *Once the contour of the face is established, sketch in each of the facial features. The eyes line up with the horizontal line, while the nose lines up with the vertical line.*

4 *Finally, add in the finishing touches, and clean up any construction lines.*

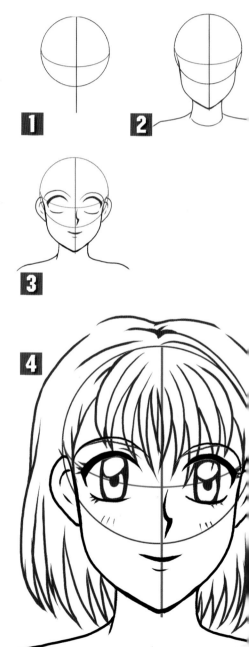

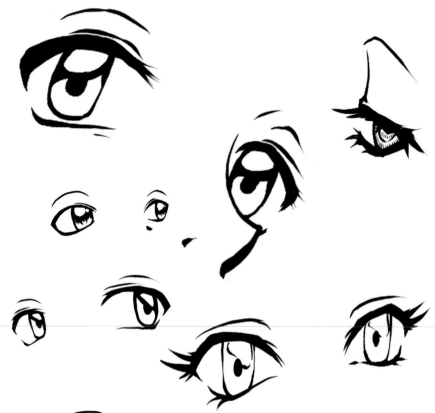

▲ There are unlimited ways to depict a character's eyes depending on what qualities you would like to emphasize.

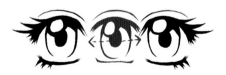

▲ As a rule of thumb, the space between a character's eyes is approximately the length of one eye.

▼ Playing around with the spacing of the eyes can make for an interesting-looking character, but be careful with the degree of exaggeration you take. Spacing them too far apart (*top*) or too close together (*bottom*) can make the character look a little strange. Either way, the character looks wrong.

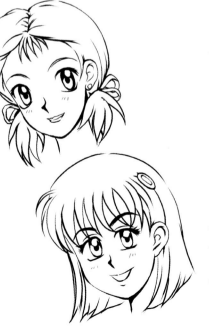

EYES

The eyes are arguably the most important feature of the face. They tend to grab the attention of your viewer first, and help convey the mood and emotion of your characters.

Size

Although large, sparkling eyes are a staple feature in manga and anime, it is just as common for characters to have smaller eyes. How you choose to draw eyes depends on your stylistic preferences as well as the personality of the character.

Large eyes are considered more appealing and attractive than smaller eyes, which is probably why they are so prevalent in manga-style artwork. The exaggerated size of the eyes allows them to convey more emotion. They can appear open and inviting, sweet and feminine, or innocent and childlike. Given these qualities, they are often utilized when drawing women and children.

Smaller and more angular eyes are often utilized when drawing masculine, mature, serious, or tough characters. Therefore, males are often depicted as having smaller eyes.

Large and small eyes don't always indicate gender. Gentle males may sport large eyes to emphasize their femininity. Likewise for tough female characters – smaller eyes can help give them a more masculine or mature look.

Position

The eyes are positioned in the middle of the head, sometimes slightly higher or lower. They are spaced approximately an eye-length apart from each other.

Style

This step-by-step diagram goes through the construction of an eye. To reiterate, this is just one method for drawing the eyes. Keep in mind these general guidelines, then look at both realistic eyes and how other artists draw manga-style eyes, and experiment to develop your own style.

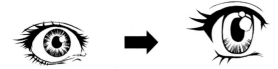

▲ There are numerous ways of adapting a realistically depicted eye into a manga-style eye. As a basis for your manga-style eyes, I recommend working from life. Observe the key features before transforming it into a more simplified and exaggerated manga form.

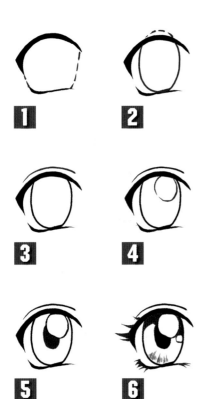

1 *First, draw the upper and lower eyelids to form the general shape of the eye. The dotted line indicates the edge of the eyes.*

2 *Draw an oval to represent the iris. Note the dotted line, which indicates the unseen part of the iris covered by the eyelid. The iris generally touches both the top and bottom eyelids, unless the character is looking up or down or is surprised.*

3 *Draw a line to indicate the fold of the upper eyelid.*

4 *Draw a circle to indicate the primary source of reflected light. This is typically drawn on the side of the eye closest to the light source in your picture.*

5 *Draw a circular black pupil in the centre.*

6 *Additional details such as dark shading along the top, additional sparkles, and eyelashes can now be added.*

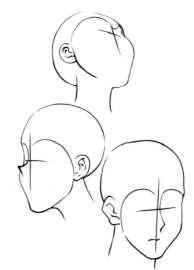

EYEBROWS

Eyebrows come in a variety of shapes, sizes, and colours (thick, thin, bushy, black, coloured, tapered, etc.). Males tend to have thicker eyebrows, but don't be afraid to mix and match. Eyebrows go a long way toward making each character you create look unique.

Position

The eyebrow connects with the bridge of the nose. Drawing the whole structure (even if you plan to omit the nose bridge) will help you spatially arrange the facial features.

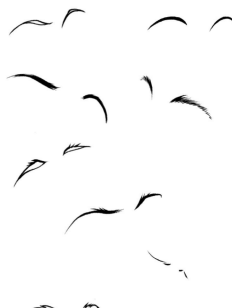

▲ The eyebrows are one of the most characterful parts of the facial features and you can have some fun with the way you match them to your character.

◄ Drawing your character's head from different angles will enable you to get a good overview of how the structure of the features will work.

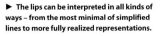

▶ The lips can be interpreted in all kinds of ways – from the most minimal of simplified lines to more fully realized representations.

◀ The horizontal guidelines indicate the relation of the ears to the character's eyebrows and nose. The dotted line along the bottom of the face shows how the jaw connects to the base of the ears. Also note how both eyes fall within roughly the centre of their related sides of the face, even with the distortion from the three-quarter head angle.

▲ Manga-style noses have a recognizable, often 'coquettish' character, requiring minimal interpretation.

EARS

Position
The ears generally fall between the brow line and the base of the nose. The jaw line extends from the chin to the ear.

NOSE

Position
The tip of the nose is positioned half-way between the eyes and the chin.

Style
There are numerous ways to depict the nose. It tends to be de-emphasized in manga-style artwork, often drawn as a small triangular tip, or sometimes even omitted altogether. Depicting the bridge of the nose can make the character look older and more sophisticated. On the other hand, larger, realistic, and exaggerated noses can give the character a more unique appearance, or indicate race/ethnicity.

To give the nose form, try adding some shadows below or to one side of the nose.

MOUTH
The mouth is another component of the face crucial for conveying emotion.

Style
Mouths are highly simplified. A closed mouth can be designated by a single line, with an additional shorter line beneath it to represent the lower lip.

Additional lines, shading, or colour can be used to make the lips more detailed and pronounced. These lips, reserved for female characters, work as visual shorthand that gives the character a mature and sophisticated look.

TEETH
Teeth tend to be either omitted, or heavily simplified. To give the character a toothy smile, teeth can be drawn as the simplified block (rather than as individual teeth).

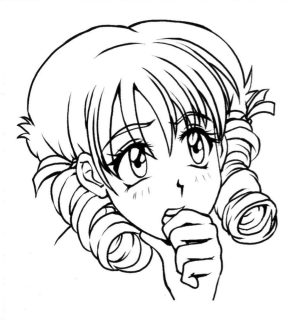

▲ In the world of the purely linear, things like blushing cannot be expressed with colour or tone. Instead, a kind of shorthand has been developed to express these features through the use of lines. Vertical dashes on the shy girl's cheeks make her look as though she's blushing.

CHEEKS

Vertical dashes can be added to the character's cheeks to suggest roundness or blushing. The more dashes, the more blushing. Blushing is also sometimes depicted as red ovals on the character's cheeks.

HAIR

Position

It helps to first sketch the outline of the character's head. The head may end up misshapen or too small if you attempt to draw the hair first without considering the shape of the head. Also note the hairline, which starts approximately three-quarters of the way up the head. When drawing in the hair, leave some space between the outline of the head to give the hair a fuller look.

Style

There are many different techniques for rendering the hair. Some artists depict the hair as solid sections, while others prefer to indicate individual strands. Likewise, hairstyles range anywhere from commonplace to gravity defying. Whatever the style, always keep in mind that the hair grows from the head, so make sure all strands flow from that direction. Hair is another defining feature that sets your character apart from others, so be creative with your designs.

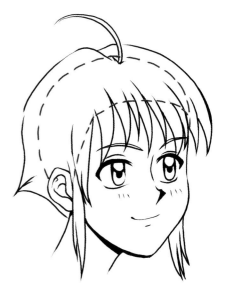

▶ The dotted lines indicate the hairline as well as the back of the character's head, over which the hair can be placed.

▼ There's more than one way to draw hair. The first example (*bottom left*) shows simplified hair that depicts each portion of the hair as almost a basic outline. The second example (*bottom middle*) is much more involved, using contour lines to define the body of the hair, thus giving it a more detailed look. The final hairstyle (*bottom right*) illustrates the latitude you have when creating manga-style hair – even hair that defies gravity.

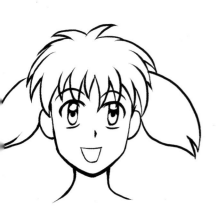

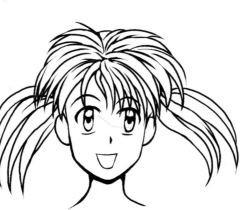

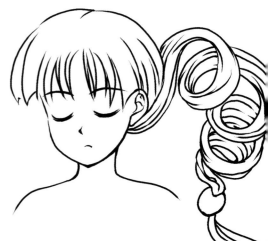

IMITATION VERSUS IMAGINATION

Once you have a good understanding of the basic proportions, you'll want to start working towards making your drawings stand out, and a good part of that lies in developing your own unique style. One way of making your style identifiable is to find many sources of inspiration and combine them into a style that is your own.

This makes manga-style artwork a tricky subject to learn. Artists can further their ability to create realistic works of art by working from real-life models, but what sources do you draw from when you're working in a style that has no real-life equivalent?

A lot of novice artists start out by copying other artists' works or stylistic nuances. This is a good way to practise and become acquainted with how manga-style artwork is structured, but remember that it is only a learning tool, not a drawing crutch. Copying leads to stagnation, since in the end you're producing a copy of a generic anime face and body in the style of a popular artist you like. Therefore, once you're comfortable with the basics, move beyond that step by critically thinking about why the artist you are mimicking draws the way they do and why you like the style so much.

Observe how they draw their characters: the size and shape of the eyes, nose, mouth, head, and so on, where the sparkles are placed in the eyes, how long the legs and arms are, the type of body, etc. Study their linework and colour palette. Then decide what exactly you like about these artists' styles. Perhaps you like the way one artist gives his characters extremely large eyes and contrastingly small mouths. Perhaps

you like the way another artist draws his characters with long fashion model legs, but a small, bulky frame. Maybe you like how another artist draws hands and feet, and flowing strands of hair. Take these preferences and apply them to your own drawings.

Don't stop at just your favorite anime manga artists. Inspiration can come from anywhere. Studying classic painters and contemporary artists can lead to discovering new styles and techniques. Inspiration can also come from real-life objects. Look at nature, animals, man-made structures, and so on. Even fruits and vegetables can become a source of inspiration!

Through much practice, revision, and modification, you will discover that your style has developed into its own unique design.

▲ (*Left*) Image from Ohse Kohime Illustrations. (Image by Oshe Kohime, copyright Bijutsu Shuppan-Sha, Ltd.) Oshe Kohime has a knack for whimsical costumes. Her characters often sport full, red lips, large eyes, and large hands and feet.

▲ (*Right*) Image from *Intron Depot 2*. (Copyright/image by Masamune Shirow.) Masamune Shirow often draws mature and sophisticated-looking characters. Some hallmarks of his heavily detailed style are the athletic and elongated figures on his characters.

▼ Image from *Final Fantasy X-2*. (Image by Tetsuya Normura, copyright 2003 Square Enix Co. Ltd.) Tetsuya Nomura creates characters who tend to have more realistic figures and faces than other manga-style artists.

▼ Image from Satoshi Urushihara's *Cell Works*. These characters are typical examples of his drawing style – although, here, they do appear dressed. (Urushihara is otherwise known as 'the master of breasts'.)

REFERENCE

A good understanding of anatomy is the most important key to creating new and exciting poses. There are all kinds of resources that you can use as reference for poses and this section looks at some of them.

When you are ready to draw your characters, think about the kinds of poses you want to use. Try to be original and creative. Avoid static poses such as a straight-on shot of a character standing in position. Depending on the situation, basic poses may sometimes be appropriate, but don't let this be the only type of pose you draw. Give your characters personality! Draw them from dynamic angles, or show them in action. Challenge yourself.

RESOURCES

Resources that you can use for getting reference for your drawings are as follows:

Model

Drawing from a live model is one of the best ways to learn about the human figure. If you can't afford the services of a professional model, ask your family or friends to pose for you.

Mirror

A mirror allows you to be your own model. Be creative and imaginative, and try a variety of poses in the mirror. When you find one that works for your picture, try drawing it.

Camera

A digital camera comes in handy for sketching difficult poses (especially positions that are awkward to hold or require the use of both arms). Ask a friend to snap some photos of you in your desired pose, or vice versa.

Magazines

Fashion and fitness magazines are good for studying anatomy as well as clothing and hairstyle reference. They are filled with people wearing a wide variety of clothes in many different poses.

However, be careful not to rely too heavily on this resource. Because the primary purpose of fashion photography is to showcase the model's clothing, poses tend to look unnatural.

Remember, too, that photographs are copyrighted. If your artwork is substantially similar to the photograph, you must acquire permission from the photographer.

Poses from magazines limit your creative freedom. Body language, expression, and pose are all important elements that you as the artist need control over to fully convey your message. It is better to conceptualize your own pose ideas and use one of the other resources listed instead.

Books

Pose books, available in the art section of good bookshops, feature models posed in various positions (everything

▲ Leave the high-end cameras to professional photographers. Any moderately good digital camera can be useful for gathering reference material.

from running and jumping, to sitting and standing), photographed from every angle, in various states of dress and undress.

Software

Many artists use a 3D program called Poser as a resource for figure anatomy. It's reasonably priced and easy to learn. You can pose the figures (male, female, skeleton, wooden mannequin, and child, to name a few) in any position you desire, and even adjust the lighting.

▲▶ Books like *Dynamic Anatomy*, *What People Wore*, and even fashion magazines are all fantastic sources for reference material.

Wooden mannequins

The wooden doll is a stylized and simplified version of the human figure, and can be posed in various stances. Despite being jointed, its range of motion is severely limited, so it might not be capable of performing unusual positions. Nonetheless, they're inexpensive and available at most art supply stores.

Action figures and character models

Available through comic book and specialist shops, as well as anime conventions, high-quality character models can be used not only for pose reference, but also as a helpful guide for anime character anatomy and facial structure. Find figures with faces and bodies that suit your existing or desired style.

Be sure to also peruse reference materials for drawing clothing, objects, hair, drapery, animals, cars, and so on. Work toward compiling a library of books: on history, architecture, interior design, fashion, furniture catalogues, clothing, and household items. Even children's books can be useful – the text may be basic, but they are often filled with large photos covering a wide variety of subjects.

▶ Using a 3D program such as Poser can be a useful resource for anatomy.

▶ These sketches, done after carefully studying the distinguishing characteristics of real crustaceans found in a children's book and from photos taken at a local aquarium, led to the creation of a frightful creature featured in the graphic novel *Peach Fuzz*.

▼ High-quality character models are widely available from comic book and specialist shops.

3

PREPARATION

By now you should have a picture that's ready to be integrated into the digital realm. But before you can enter this exciting world, there's still some preparation left to do.

Preparation involves purely technical processes that require little creativity, making it one of the least exciting aspects of digital manga creation. However, how you set up your image can determine the overall quality of the piece, making it a vital process to understand.

It begins with scanning – the process of transferring your artwork on to the computer. In order to produce a decent scan, you must know which type of scanner you need, how to prepare an image for scanning, and which settings to use.

A term related to scanning is 'DPI', a measurement of image resolution for printers, scanners, and monitors. See the section on DPI for an in-depth explanation of the subject which should demystify this extremely important element of digital art.

SCANNING

Scanning is the process of transferring an image on to a computer for digital editing. Compared to the other steps involved in digital image-creation, it's quick and simple, but this doesn't make scanning less important. A good scan means crisper, better-looking artwork.

PURCHASING A SCANNER

Type
I recommend the flatbed scanner, as it has the ability to scan images regardless of whether they are on a single sheet of paper or in a sketchbook.

Size
The size of the scanner should measure around 8.5 x 11in. Scanners are manufactured in sizes larger than 8.5 x 11in, but can cost anywhere between hundreds to thousands of pounds more.

Capabilities
The scanner should be capable of scanning in both colour and black and white, at a minimum of 300 DPI with a colour depth of at least 24 bits. Most flatbed scanners on the market meet these requirements, so you shouldn't have any trouble finding a scanner you like within your price range.

PREPARATION
The following is a list of pre-scanning guidelines.

- Draw on smooth, white paper, as the tiny grooves in toothed paper can appear as graphical noise. The more bright and opaque the paper is, the better.

- Completely finish your drawing first. Drawing directly on to the computer isn't as easy as drawing on paper. Once the image is scanned, it becomes difficult to make changes.
- Unless you intend to digitally ink your picture, darken up all your lines to ensure that you are rewarded with the best scan possible.
- Erase any stray pencil lines and smudges from the picture. It's easier to clean these unwanted blemishes before the image is scanned.
- Make sure that the scanner window is free of dust, smudges, etc.

SCANNER SETTINGS

Colour
If your artwork has already been coloured, scan it in full colour mode (24 bit/16 million colours). As a rule of thumb, colour modes other than full colour should be avoided. Web colour, for instance, usually scans and converts the image into a 256- or 216-colour GIF.

Black and white (Line art)
This is a two-colour mode: black and white. Pictures scanned in black-and-white mode have no anti-aliasing, so even when artwork is inked tight, thin lines and details can disappear or become broken. Black-and-white line art mode works very well when scanning text for OCR, but shouldn't be used for artwork.

▲ Scanner interfaces come in a variety of looks with many different settings, but they should all have the same basic functionality.

Greyscale
Always use this mode for black-and-white artwork, whether it's a pencil sketch, or inked line work. Greyscale mode scans in 256 levels of grey tone, giving the line work soft, anti-aliased edges, and rendering thin lines as grey rather than invisible. Lines can sometimes appear light, but with a bit of image clean-up, they can look sharp and dark without being thick and blobby like a picture scanned as black-and-white line art.

SCANNING YOUR IMAGE

When your picture is ready to be scanned, place it in the scanner. Line up your picture with the edge of the scanner to avoid scanning it at a skewed angle. If the picture is larger than the scanner bed, you'll need to scan it in multiple parts and then carefully piece the parts back together using image-editing software. If possible, keep the lid closed to minimize the amount of outside light entering the scanner.

▲ This shows how to position large drawings so that they can be scanned in two parts.

◄ Once the parts are scanned, they can be pieced together in a graphics application, such as Photoshop.

► Carefully align and overlap the parts so it makes a complete and unbroken image. This isn't an exact process. Any slight misalignments can be cleaned up later.

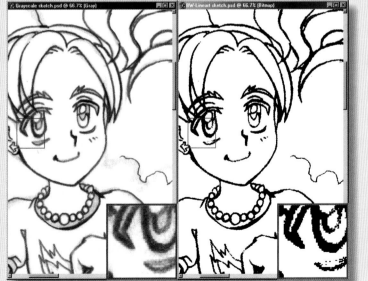

◄ Even when great care is taken in the line work, scanning in black and white (*left*) has the tendency to drop softer lines and coarsen darker lines. Scanning in greyscale (*far left*) picks up more of the detail, and allows more avenues for editing.

DPI

DPI stands for 'dots per inch'. It measures resolution, and determines the detail and clarity of an image. Depending on how you wish to use your finished manga-style artwork, you will need to save your images at differing resolutions, or DPI.

WHAT IS DPI?

DPI is an easily misunderstood abbreviation. It is often confused with PPI (pixels per inch) and SPI (samples per inch) which are different. DPI measures resolution, and determines the level of detail and clarity of an image. If you intend to print high-quality versions of your images, you'll want to scan and work on your image at around 300 DPI. If you're only planning on publishing images on the Web however, you only need think of DPI in terms of the image size on screen.

When scanning, more DPI simply means a larger, higher-resolution image. This means that an image scanned in at 300 DPI will print with a finer grain than an image scanned in at 100 DPI.

72 DPI

You may have heard about the so-called 'magical' number 72 as being the DPI at which monitors display images. This is untrue. Monitors don't display images in terms of DPI. Monitors display pixels, and the higher the monitor's resolution is set, the more pixels appear on screen.

The more pixels in an image, the larger the image. The amount of pixels in an image is determined by the DPI setting you choose when you scan your image.

So where does DPI come in? Printing and scanning. In scanning, DPI tells the scanner how many pixels to acquire per inch of image being scanned. Once on the computer, these pixels are no longer bound by DPI settings. Then, for printing, the DPI number tells the printer how many dots of pixel data to represent on an inch of printed paper space.

▲ DPI determines the number of dots contained within a square inch. The more dots, the higher the resolution.

◄ These three examples show the same image scanned in at 100 DPI (*left*), 200 DPI (*middle*), and 300 DPI (*right*). As the DPI on the scan is increased, so is the size and clarity of the detail within the image. Line work scanned at 200–300 DPI should pick up all of the nuances of the illustration.

WHAT DPI TO USE

If you're scanning a finished image that you intend to place directly on a webpage, scan at a low DPI (50–250 DPI, depending on desired size). If you're scanning artwork that you intend to digitally ink, colour, or otherwise edit, you should scan around at least 300 DPI so you'll have a decent-sized image to work with. This can later be resized to your preferred viewing size for Web purposes. An 8.5 x 11in image scanned at 300 DPI creates a large image around 2,550W x 3,300H pixels on screen (8.5 x 11 x 300 DPI), a good size for detailed image-editing (without being too large for your computer to handle) and the perfect size for a photographic-quality print.

If you are uncertain which DPI to scan an image at, choose 300 DPI, as you can always decrease the size of the image later without affecting the quality of the image. Scaling down the image reduces the number of pixels by blending pixels together, but doesn't reduce the visual quality.

On the other hand, never increase the size of the image once it's scanned. Increasing the size creates fake filler pixels, called 'interpolated' pixels, to help fill in the larger image area, thereby reducing the quality of the image.

▲ Original size. Details are sharp.

▲ Double size. When blowing up a picture to a new size, the graphics software must make new pixels to fill up the now larger space occupied by the image. These fuzzy-looking interpolated pixels detract from image quality, and get worse the larger the image is sized up.

▲ Half size. Image retains its sharp quality, but loses some of the detail as the number of pixels is reduced.

◄ On a monitor, the DPI setting of an image is meaningless, but when printed out the DPI setting can have quite an impact. The same 300 DPI source image is printed twice, once at 300 DPI (*right*) and once at 30 DPI (*left*). Because of the DPI setting, the one at 30 DPI physically prints out only 30 x 30 pixels of data per inch of actual paper. At this setting you would need 72 pieces of paper to reproduce the image in its entirety.

IMAGE CLEAN-UP

After an image has been scanned, the next logical step is image clean-up. This is the process of removing unwanted elements from a scanned image (smudges, grey areas, digital noise, stray lines, etc.), as well as sharpening and darkening the image in preparation for colouring. Photoshop is the best candidate for image clean-up.

BRIGHTNESS/CONTRAST

Brightness and Contrast sliders are useful for darkening the line work and increasing the brightness of the paper.

Brightness controls the amount of light and dark in an image. Increasing the brightness helps eliminate unwanted grey tones. Avoid decreasing the brightness below 0. A negative number darkens lines, but causes the white paper to go grey, which is an undesirable effect.

Contrast sharpens the divisions between tones. Too much brightness can bleach black lines. Gradually turn up the contrast to counterbalance this effect. Increasing the contrast replaces a soft gradation of the tones with sharper black-and-white divisions. For image clean-up, contrast in the 10–50% range should effectively sharpen and darken the line art to a pleasing degree. Be careful: too much contrast will make your line art look jagged and clumpy.

REPLACE COLOR

Another helpful tool for the reduction of grain and image noise in an image is the Replace Color option (select Image>Adjust). It can be used alone or in coordination with the Brightness/Contrast sliders. Using Replace Color, lighter grey tones can be selected based on colour value and then replaced with white.

The Replace Color Eyedropper tool is similar to the Eyedropper tool on Photoshop's palette, which allows colours to be easily selected from within an image. The only difference is that the colours chosen with Replace Color's Eyedropper tool are replaced with a different colour (white for the purpose of clean-up). The second Eyedropper tool, denoted by a plus sign, allows you to select more than one tone if necessary.

The Fuzziness slider controls how tones similar to the selected colour are influenced. To give an example, if an area of pure white is selected with the fuzziness set at 0, only white would be altered by the Replace Color command. Increasing the Fuzziness slider causes

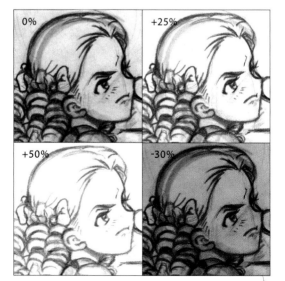

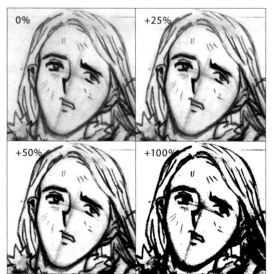

◄◄ **Starting with the original scan (0%), the image's brightness is adjusted. At around +25% brightness, much of the background noise is reduced and the line art becomes clearer. At +50%, the image starts to become washed out. Avoid negative brightness (-30%), as it will only make your lines harder to see.**

◄ **Again, starting with the original scan (0%), the image contrast is increased gradually. At around +25%, the line work becomes clearer. At +50%, some of the darker lines become completely black, but overall, the line quality is enhanced. At +100%, the line work becomes thick, completely black, and most of the detail is lost.**

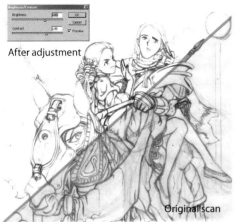

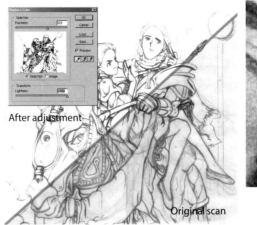

▲ Brightness and Contrast sliders are gradually adjusted to clean up the image. In this example, the brightness was set to +30 and the contrast to +35.

▲ Replace Color can be used alone or to augment Brightness/Contrast. In this example, Replace Color is used to clean up the original scan, yielding results similar to Brightness/Contrast.

the effects of Replace Color to spill over into other near-white areas. This slider needs to be adjusted on a case-by-case basis. Start with 10% fuzziness and adjust the slider until an acceptable level of grey tones is removed.

Lightness controls how the selected image data is altered. Increasing lightness brightens the selected tone. For the purposes of clean-up, always turn up lightness to 100%.

RETOUCHING

The Eraser tool can be used to remove any remaining smudges, stray lines, and other undesirable articles that weren't removed by the preceding steps. For best results, set the Eraser tool's opacity and hardness to 100%.

The Eraser tool can also be used to clean-up and enhance well-defined line work by removing unclipped lines. In traditionally inked images, lines may bleed into each other. While they aren't readily noticeable unless the artwork is closely scrutinized, their removal can help improve the quality of the image.

MISSING LINES

Double-check for unintentional broken segments in the line work. Take care to make your digitally added lines similar in appearance to the original line work.

TRANSPARENT LINE ART

Many methods of digital colouring and line work manipulation require you to place the line work on a separate layer from the background. This section will show you how to transfer your line art onto a new transparent layer, allowing free and simple manipulation of the line work whenever required.

ISOLATING THE LINE WORK

It's easy enough to copy and paste the background layer information on to a new layer, but that doesn't solve the problem: isolating the line work so that the black lines and white portions are separate.

Photoshop assigns a colour mode to scanned artwork based on the colour mode specified in the TWAIN interface during the initial scan. If the image is scanned as greyscale, the image will be set to greyscale mode. This is fine for clean-up or corrections, but change the mode to RGB colour when you start colouring. Choose Image>Mode>RGB.

CREATING TRANSPARENT LINE ART

Next, select the Channels palette. There should be a list of colour channels (red, green, and blue) and possibly saved alpha channels. Located at the bottom of the Channels palette are four buttons used for general channel functions. Click on the leftmost button, the one that looks like a circular marching ants selection. This button loads the channel information as a selection on the image, thereby selecting all the white areas, and masking all the black areas. We want to select the black areas, so choose Select>Inverse to reverse the selection.

Select the Layers palette. Create a new layer and fill the selection with black. This will place the black line work on

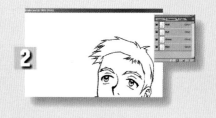

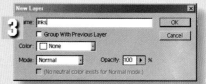

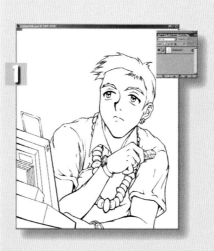

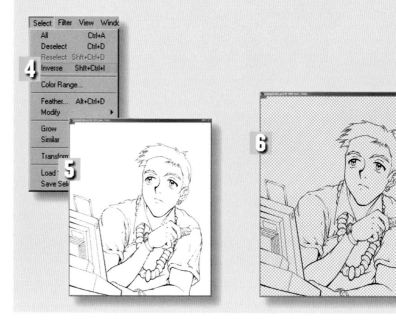

the fully transparent layer above the background layer. Next, choose the background layer and choose Select>All. Fill the selected area with white. Finally, save the file as a PSD and the process is complete. The resulting line work should contain clean, black lines on a transparent layer, ready for use with any colouring method.

1 *Start with your line art as the background layer.*

2 *Click on the selection mask icon on the Channels Palette to select the white portions.*

3 *Create a new layer titled 'inks'.*

4 *Choose Select>Inverse to invert the selection.*

5 *The black lines are now selected.*

6 *On the new 'inks' layer, fill the selection with black.*

7 *Finally, fill the background layer with white.*

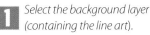

1 *Select the background layer (containing the line art).*

2 *Cut and paste the layer, making a new layer above the background.*

3 *Set the new layer's composition method to Multiply.*

4 *Move the line art above any colour layers, and colour the image.*

USING MULTIPLY

It isn't always important for line art to be separated on to its own transparent layer. For most general-purpose jobs where the line art is considered complete and doesn't need to be modified, floating the line art on a layer set to Multiply accomplishes the same goals.

To do this, simply select the background layer with the line art, cut, and then paste it. The line art will be placed on its own layer above the background. Change its composition mode to Multiply and now any layers that show up underneath it will become clearly visible.

Keep in mind that since this method relies on the Multiply setting to achieve transparency, all underlying layers will interact with the line art according to the dictates of the Multiply setting. If the line art is not completely black, as is often the case with pencil work, underlying colour layers can substantially darken or blacken the lines. In some cases this can actually work for the image, making lines naturally become darker in areas where underlying colour is also darker.

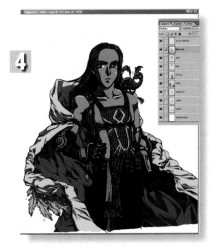

SAVING

Saving is the computer's way of making something permanent. When working in a graphics application, every stroke of a brush is stored temporarily in the computer's memory. However, to be permanently preserved, the computer must write information out of memory to a more permanent location. This process is called saving.

WHICH FILE FORMAT?

There are a wide variety of different file formats (PSD, RIF, BMP, JPG, and so on) for saving images, each with their pros and cons. Some retain an image in perfect detail in exchange for a large chunk of hard disk space, while others terribly degrade the quality of the image, but hardly take up any space. Some only work in a single application, while others work in a broad range of applications. No image file is perfect for all situations, so it's important to know where each file format excels.

GETTING ORGANIZED

One of the most important things to note while you are working on a project, is to be sure to save frequently! There's nothing worse than spending hours on a picture without saving, only for the program to crash or the power to momentarily flicker off. To save an image, choose File>Save As, select the file format most suitable for the situation (as described in detail below), and give it a unique file name, then choose Save.

In addition, Painter is notorious for corrupting saved files, which normally means destroying whole pictures. The only way around this disastrous event is to save multiple copies of your file ('inks1', 'inks2', and so on) so you'll be able to return to a previously saved file, if necessary.

I recommend compiling your images on CD-R or DVD-R to protect your artwork from being lost in a hard drive crash, and to ensure that you have a high-quality version of the image for later use.

WORK IN PROGRESS AND ARCHIVAL FILE FORMATS

I recommend that you preserve an archival copy of your image. This ensures that you'll always have a high-quality version of the image to work from should you need to resave, print, or edit the image later. This will also protect your artwork from being lost on that horrible, black day when your hard drive crashes, destroying all the information contained on it. This section details specific file formats that are optimum for work in progress and archival purposes and which media are best for backing up your images.

The main concern here is quality and compatibility as opposed to size. File formats that degrade in quality, such as JPG, and/or don't retain layers and other important data, are unsuitable.

PSD

Photoshop's proprietary image format. PSDs are a robust format widely accepted by many graphics applications. When working in Photoshop, the PSD is the only file format that will retain all the working information (layers, paths, etc.)

```
Photoshop (*.PSD;*.PDD)
RIFF Files (*.RIF)
Mac PICT Files (*.PCT)
BMP (*.BMP;*.RLE;*.DIB)
CompuServe GIF (*.GIF)
Photoshop EPS (*.EPS)
Photoshop DCS 1.0 (*.EPS)
Photoshop DCS 2.0 (*.EPS)
JPEG (*.JPG;*.JPEG;*.JPE)
PCX (*.PCX)
Photoshop PDF (*.PDF;*.PDP)
PICT File (*.PCT;*.PICT)
Pixar (*.PXR)
PNG (*.PNG)
Raw (*.RAW)
Scitex CT (*.SCT)
Targa (*.TGA;*.VDA;*.ICB;*.VST)
TIFF (*.TIF;*.TIFF)
```

▲ **On the computer, many different media retain image data. These are known as file formats, which are denoted by a three-letter extension to the file name, such as PSD, RIF, TIF, BMP, JPG, GIF, and so on. It's important to know which format is best for a given situation.**

▼ **PSD, RIF, TIF, JPG, and GIF are the primary formats you'll be working with for the purpose of digital art.**

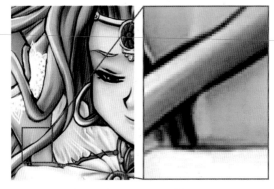

▲ Cropping of an image saved as a 12-quality JPG file. The file is too large for general use on the Web, but contains no discernable compression artifacts. 120.5KB.

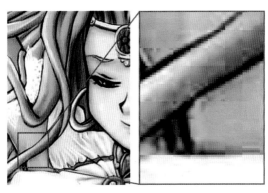

▲ The image saved at 7-quality represents one of the better trade-offs between image quality and file size. 36.3KB.

▲ At 1-quality, the image's appearance takes a dramatic downturn due to the effects of JPG compression. 16.1KB.

a picture contains. PSDs preserve the image at full quality. It can also save image data in any colour mode.

In comparison to other formats (TIFs and BMPs), PSDs are reasonably small. Image size, layers, channels, paths, text, notes, etc., can influence the file size, but most 8.5 x 11in images, with a modest amount of layers, remain within the 15MB to 50MB range. Note that PSD files saved in Painter tend to be larger than the Photoshop equivalent. To fix, resave the file in Photoshop.

Compatibility
PSDs can be opened, edited, and saved in all versions of Photoshop and in later versions of Painter and Paint Shop Pro. Be cautious when exporting a PSD file to applications besides Photoshop (or even older versions of Photoshop). PSDs are complex, and even if the program is capable of reading the file format, it may not render the file correctly.

RIF
Painter's proprietary image format. Like PSDs, RIFs store all information and settings without any loss in quality. They are the only format that can retain Painter's information regarding watercolour tools, impasto, wet layers, standard layers, and shapes.

Compatibility
The deal is that RIF files are only compatible with Painter. If your image requires editing outside of Painter, it can be resaved as a PSD for Photoshop. Be sure to keep a backup of the RIF if your file contains any Painter-only features.

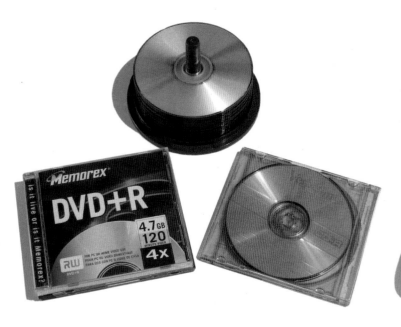

◀ CD-Rs and DVD-Rs are an ideal, cost-effective way of preserving your images.

▼ A CD booklet in a secure place is a good way of keeping your treasured archive safe.

TIF

TIFs preserve alpha channel information, and can be saved in all colour modes, but, unfortunately, won't preserve layer data. The colour depth of the image determines the file size. To help reduce the file size, a form of lossless compression commonly known as LZW can be employed.

Compatibility

TIFs are one of the most widely supported file formats for storing graphic information. Because they are compressed, flattened, and full quality, publishers and print shops generally prefer them to other file formats.

MEDIA

For backup purposes, I recommend compiling your images on CD-R or DVD-R to protect your artwork from being lost in a hard drive crash, and to ensure that you have a high-quality version of the image for later use.

The CD-R drive itself is very affordable, as are the readily available blank CDs. CD-Rs can save in the region of 650MB to 700MB per CD, which in most cases means approximately 10 to 20 complete image projects can be archived on a single CD-ROM. That's not a bad deal. DVD-Rs are slightly more expensive, but can store in the region of 4.5GB – almost seven times more space for data.

One other way to backup information is to save the file on multiple hard drives, thereby ensuring that if one drive fails, the images will still be contained on the other. I wouldn't recommend this method because there can be situations where the information on both hard drives is affected. For example, if one particularly nasty virus happens to execute on your computer, say goodbye to your images (and everything else for that matter).

WEB FILE FORMATS

If you intend to publish your images on the Web, you'll need to save a copy as a JPG or GIF. Large file formats such as PSD and RIF are unsuitable as they're massive and don't display in Web browsers.

Remember to resize your images down so that they are easily viewable at average resolution within a Web browser window.

JPG

The most widely used and accepted file format for Web publishing. The file size is relatively small, and they can be saved in RGB colour mode, making them the best choice for most colour images.

JPGs utilize lossy image compression, which helps conserve file size but reduces the quality of the image. The higher the compression setting, the more deteriorated and corrupted the image becomes.

◄◄ Cropping of image saved as a 7-quality JPG file. 55KB.

◄ Image saved as a 64-colour GIF file. This version contains very little noticeable dithering and manages to edge out the JPG in file size. 43KB.

▼ Image saved as a 16-colour GIF file. This version of the image has the lowest file size, but the loss of colour throughout is quite apparent. 28KB.

When you choose to save an image as a JPG, you'll be presented with several options, including a quality scale that ranges from 0–12. 12 produces the highest-quality image possible, but also the largest file size. 0 produces a very coarse image with a much smaller file size. 7 offers a good balance between quality and size.

Never save a JPG more than once, as it'll continue to deteriorate in quality. If the image in question must be edited, return to the original PSD file and work from that.

GIF

GIF is a file format good for images with a monochrome or limited colour palette as well as animated and transparent images. As GIFs are limited to only 256 colours, images with a wide variety of colours should be saved as JPGs instead. It uses lossless compression methods, allowing it to retain all image data without degrading the quality.

While GIF images are limited to a maximum of 256 colours, they can be set lower to benefit from a substantial decrease in file size. There are instances where an image will only require a certain number of colours, like in the case of black-and-white line art, which only requires somewhere between 2–16 colours. Be sure to adjust the amount of colour on the GIF appropriately. If the image only has eight distinct colours in it, specifying a higher number does nothing except increase the file size.

4

PAINTER AND PHOTOSHOP BASICS

Photoshop is the standard in image software. It's robust and powerful, loaded with tools, brushes, filters, layers, masking options, and more. It's the crème de la crème when it comes to digital image-manipulation, and works quite well for colouring images – even traditional-style paintings.

Painter is the application of choice if you're trying to achieve a natural media look. Painter's extensive collection of traditional art supplies such as charcoal, watercolour, pencil, oil, acrylic paints, and inks can all be replicated. However, spending the time trying to figure out what options need to be tweaked in order to create a brush that captures the right natural media look can be enough to stifle your creative energy.

Both applications are complex. There's nothing more frustrating than to not be able to find the right tool for a desired effect. This chapter introduces you to the world of Adobe Photoshop and Corel Painter, the primary tools in the creation of digital artwork, and helps you to get the most out of each program. Understanding how to use the tools, palettes, and functions for maximum benefit will allow you to acquire a higher level of proficiency with your art. More time to focus on your artwork, and less time wasted looking for the right tool.

INTRODUCTION TO PHOTOSHOP

Adobe Photoshop is the industry-standard program for digital art, due to its versatile ability to perform a multitude of tasks, from airbrush and cel-style colouring to composition and typography. This section introduces you to the software.

GETTING TO KNOW PHOTOSHOP

Although the palettes and menus aren't as haphazardly organized as Painter's, first-time users may find the program daunting, wondering where to begin first. To help you get comfortable within the program, this introductory section contains information and descriptions of the tools, palettes, and menus that specifically pertain to manga-style artwork.

Take some time to browse the Help File in Photoshop. It's exceptionally useful and comprehensive, containing helpful information about navigating and using the program.

All of the screenshots pictured come from Adobe Photoshop 7.0. If you're using a different version of Photoshop, you may notice slight differences in appearance and location of the tools, but nothing drastic enough to prevent you from following along.

TOOLS

The Toolbar covers all the basic functions, from magnifying, selecting, and cropping the image, to adding brush strokes or text. Selecting an item on the Toolbar palette will change the shape and function of your cursor. The primary tools are readily visible, but many other tools are hidden beneath them. To access them, click and hold down your mouse button over the appropriate location to bring up a row of additional tools.

Brushes palette

The Brushes palette is extremely useful, allowing you to change the size and shape of the brush, as well as angle, roundness, texture, colour, and other dynamics.

Navigator and Info palette

The Navigator palette assists in the navigation of the image, functioning as both a Zoom and Move tool. Finally, the Info palette contains RGB and CMYK colour information, X/Y axis location, and width/height measurements.

► **Toolbar palette**

Selection tool ●
Move tool ●
Lasso tool ●
Magic Wand tool ●
Crop tool ●
Paintbrush and Pencil tools ●
Eraser tool ●
Gradients and Paint Bucket tools ●
Blur, Sharpen, and Smudge tools ●
Dodge, Burn, and Sponge tools ●
Type tool ●
Pen tool ●
Shape and Line tools ●
Eyedropper tool ●
Hand tool ●
Zoom tool ●
Foreground/
Background colour
(double click for the
Color Picker menu)
Standard/Quick Mask ●

◄ **Brushes palette.**

Options palette

The function of the Options palette varies depending on the tool that is currently selected.

Color, Swatches, and Style palette

The Color palette contains an RGB set of sliders that can be adjusted to create varying colours. I recommend using the more functional Color Picker menu instead of this palette. The Swatches palette can hold a customized collection of colours. The Style palette consists of preset layers style options.

History and Actions palette

The History palette will allow you to undo previous actions (brush strokes, selections, filters, etc.). It allows you to go back many steps, whereas the Undo option can only go back one step.

Layers, Channels, and Paths palette

On the Layers palette, new layers can be added, the composite method and opacity can be adjusted, and existing layers can be rearranged, locked, deleted, merged, or flattened. The Channels palette contains the image's colour information, but is also used for saving and retrieving selections known as Alpha Channels. The Paths palette comes in handy when using the Pen tool.

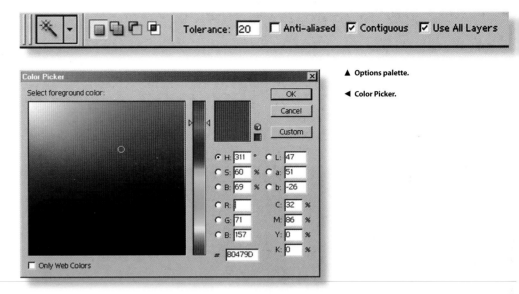

▲ Options palette.

◀ Color Picker.

▲ Color, Swatches, and Style palette.

▲ Navigator and Info palette.

▲ History, Actions, and Tool Presets palette.

▶ Layers, Channels, and Paths palette.

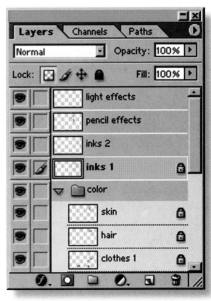

INTRODUCTION TO PAINTER

Corel Painter is a graphics application well-suited to sketching, inking, and painting. Unfortunately, it has a disorganized and confusing interface (just like a real artist's studio!). Over the years, the program has been tweaked to become sleeker and more like Photoshop, but even the newest version remains quite complex.

GETTING TO KNOW PAINTER

The user guide included with Painter is filled with information detailing almost every aspect of the program, and is a worthwhile read. However, like the program itself, the size of the book can be daunting, especially if you're already anxious to start working.

This section serves as an introduction to help get you quickly comfortable with the program. Included are descriptions of the tools that pertain to manga-style artwork, suggestions on how to customize the program, and explanations of the commonly used functions.

Note that although the program is referred to as Corel Painter throughout this book, Painter has undergone several name changes. It began as Fractal Designs Painter and later became MetaCreations Painter (Painter 5.0). Corel then bought the licence, and it became Corel Painter (Painter 6.0). In 2001, Corel began selling the product through a subsidiary, calling it Procreate Painter (Painter 7.0), but changed the name back to Corel Painter for version 8.0. Despite the name changes, all of these various Painter programs refer to the same graphics application, with the only difference being the changes between the numerous versions.

TOOLS

Toolbox

The Toolbox covers all the basic functions including brush strokes, magnifying, selecting, cropping, and text. Further customization of these functions is done through the various other palettes and menus.

Brush palette

The Brush palette contains a diverse assortment of artistic tools: pens, pencils, brushes, erasers, watercolours, dry media, to name a few. Each tool contains several variants (for example, the Eraser tool includes Gentle Bleach, Darkener, Eraser, Flat Eraser, and more). Basic brush settings (size, opacity, space, and angle, etc.) can be adjusted on the Property bar, but more advanced manipulation requires the Brush Creator window.

Color palette

Contains all the options in Painter related to colour. The essential component of this palette is the Color Wheel, which gives access to a full range of colours.

▶ Toolbar palette.
Brush tool
Layer Adjuster tool
Selection and Lasso tools
Magic Wand
Crop tool
Selection Adjuster
Pen tool
Shapes
Text tool
Shape tool
Eyedropper tool
Paint Bucket
Magnifier tool
Hand, Rotate, and Perspective Grid tools

▲ Property bar.

▲ Brush Creator window.

▲ Brush palette.

► Layers and Channels Palette.

▲ Color palette.

► Paper, Gradient, Pattern, and Weave palette.

Paper, Gradient, Pattern, and Weave palette

Allows for detailed manipulation of the paper, gradient, pattern, and weave settings.

Layers and Channels palette

On the Layers menu, new layers can be added, opacity can be adjusted, composite method and depth can be changed, and existing layers can be grouped, locked, deleted, or collapsed. The Channels menu is used for managing Alpha Channels.

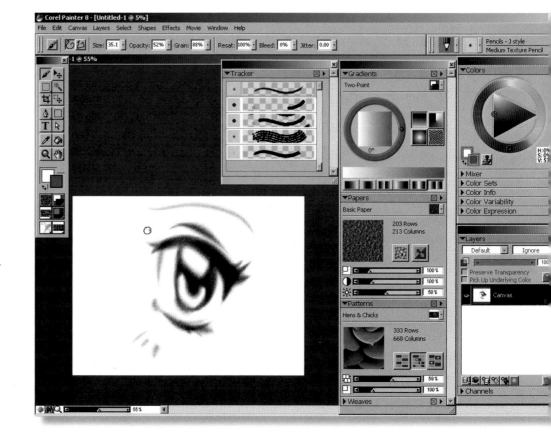

▶ **Painter's palettes and controls can easily devour the work area within the program, leaving no place to draw.**

CUSTOMIZATION

Each palette is loaded with options that use up valuable screen space, which can make Painter's interface very cluttered and disorganized. To free up some additional space for the drawing area, increase your resolution to at least 1024 x 768, hide unnecessary palettes (only extending the menus you need for your current image), and move the rest of the palettes over to one side of the screen for easy access.

ROTATING THE IMAGE

As you draw, your hand follows a normal arch of movement from down to up. Long, sweeping lines can be a problem if they don't allow your hand and arm to travel in a natural, downwards motion. If you're working with traditional media, you can just turn your paper on its side to tackle these lines. Fortunately, Painter provides a tool that's perfect for the job.

The Rotate tool is capable of rotating an image in any direction on the fly. Unlike other forms of image rotation, the Rotate tool does not permanently alter your image. It simply moves the pixel data around temporarily so you can work on your image from a more comfortable angle.

To use, choose the Rotate tool, which is hidden behind the Hand tool on the Tool palette. Click and hold the cursor over your image, then move the cursor to rotate the image into an easier position to draw.

When the image is moved using the Rotate tool, there may be some distortion, but the condition isn't permanent. Your image will go back to normal as soon as you re-centre the image. To reposition the image back to its original state, simply double-click the Rotate tool.

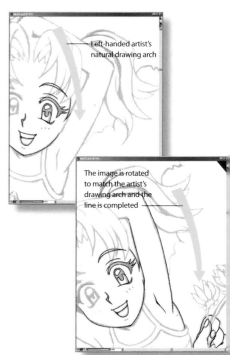

▲ **The image is rotated to give the artist a better angle to work from.**

PAPER TEXTURES

Painter's paper textures simulate the grain or texture of a surface, allowing for some rather striking special effects when used appropriately.

Unlike real paper textures, Painter's paper textures are invisible until a tool is used to express them. The papers work much like a textured surface with a plain piece of paper laid over top. When you 'rub' one of Painter's art tools against the paper, the underlying paper texture will show through.

While all tools work with the paper textures, several especially emphasize and take advantage of the paper texture data. For example, consider the Dry Media Charcoal brush. Normally, the charcoal appears as a soft, fuzzy streak of colour, but on textured paper, the charcoal takes on the properties of the paper texture selected. Many other tools, like the Watercolor tool or the Pencil tool, are also affected by paper texture to some degree.

Plain Paper

Sometimes, a visible paper texture can be undesirable. For example, in many cases, when I'm inking, the last thing I want is a grainy texture showing up throughout the line work. For whatever reason, Painter does not contain a featureless plain paper texture, so you'll need to make your own.

Click the drop-down menu on the Paper palette and choose Make Paper. In the Make Paper window, select Halftone for the pattern. Then move the Spacing slider down to 1.00, and name the paper Plain Paper. Hit OK and this new featureless paper will be available on the Papers palette.

▲▲ Just a small sampling of Painter's wide variety of paper textures.

▲ The effect of the underlying paper texture on a Charcoal brush stroke.

▼ Creating a plain paper texture in the Make Paper window.

MOVE AND UNDO/REDO

Move and Undo/Redo are three frequently used functions in both Photoshop and Painter that play an important role in digital art.

UNDO/REDO

If you make a mistake while working on your picture, there's no need to panic. Corrections can be made by simply pressing the Undo button! Undo is one of the great benefits of working digitally. Unlike traditional art, where every stroke of the pen, and every flick of the paintbrush is permanent, every action in the digital work can be undone. You can even jump back many steps if you don't like where the picture is going.

To undo your mistakes, choose Undo Brush Stroke from the Edit menu. If you decide that you want to redo the undo, choose Redo Brush Stroke from the Edit menu. In both Photoshop and Painter, the shortcut command for undoing an action is CTRL+Z. To redo an action, it's CTRL+Y.

You can increase the maximum undos allowed by changing your preferences within the program. Keep it set to a reasonable number unless you require a large amount of multiple undos, or have plenty of RAM.

▲ The line has gone astray at the bottom end.

▲ A quick CTRL+Z on the keyboard removes the line.

▲ The line is redrawn correctly.

MOVE

Most images viewed at 100% will take up more room than can be easily shown on the screen at one time. This means that, every few moments, you'll have to pause to move your image around the screen to reach the next area to work on. To help speed up the process, a quicker means of navigation around the image is required. Photoshop and Painter provide a couple of different ways to move from one area to another.

To navigate, you can use the arrows, scroll bars, and tracks along the bottom and right side of the window. In both programs, when the window of an image is maximized, arrows tend to be covered by palettes, making them hard to reach. They're also slow to adjust as they only give two possible cardinal directions of movement at a time.

An easier and speedier way to get around your image is by using the Hand tool, available on both Painter's Toolbar and Photoshop's Tool palette. Once selected, you can use the Hand to click and drag your way around the image. Once you've familiarized yourself with the Hand tool, you shouldn't have any reason to use the scroll bars on your image anymore. Maximize the image to help save screen space.

Double-clicking on the Hand tool icon will cause the program to fit your whole image on the screen at once. Double-clicking on your picture while the Hand tool is selected automatically returns you to the dead centre of your image.

Rather than selecting the Hand tool off the menu, you can use the shortcut command. All you have to do is hold down the space bar and the cursor

becomes the Hand tool. While the space bar is depressed, you can navigate freely around your image using the mouse or stylus.

In Photoshop, you can also quickly navigate with the image by using the Navigation menu, which contains a thumbnail-sized representation of your image to move around, and zoom tools. Painter has a similar feature. Clicking on the binocular icon at the bottom of the image window opens a small pop-up display of the image that you can move around.

▲ Painter's boundless image placement within a window often comes in handy when drawing or colouring near the edge of an image. In Photoshop, edges are often hard to work near because it's easy to click on or outside the window frame instead of the actual image.

▲ Photoshop's Navigator menu can be used to quickly move around an image.

WORKING WITH LAYERS

What are layers? Layers are extremely useful for both organization and editing purposes. They enable you to isolate areas of your picture so that work done on one layer does not interfere with any other, and combined together, they make a complete image.

USING LAYERS

Layers are extremely useful for both organization and editing purposes. They work like transparent sheets of paper. You can stack layers on top of each other, and still see the layers below them. Layers are opaque where you've placed pixel data and transparent everywhere else. Each layer goes over the top of the previous layer (but can be rearranged), and all combine to make a complete image.

They are most commonly associated with Photoshop, but other high-end graphic applications, such as Painter, also utilize layers. The Layers palettes in Photoshop 7.0 and Painter 8.0 are very similar in appearance and usage, so once you're familiar with the Photoshop layers, you should have no problem navigating the Painter Layers palette.

It is important to know that the more layers used in an image, the larger the image size becomes, and the more resources Photoshop or Painter will take up on your computer. The image will take longer to load and take up more hard drive space. To offset this problem, we suggest that you minimize the number of layers by combining elements of the image that aren't adjacent. For example, you could place the hair and shoe colours together on one layer.

We recommend that you give each layer a descriptive name (e.g. naming the skin layer, 'skin'). As you add more and more layers to your picture, this will make it easier to find a particular layer.

Keep in mind that only the PSD file format in Photoshop and the RIF file format in Painter 6.0+ will correctly preserve layers data. If you save your image as a JPG file, it will cause all layers to flatten. Therefore, keep an unflattened PSD (if space allows) so that you'll always have an uncompressed, unflattened version of the image to use if necessary.

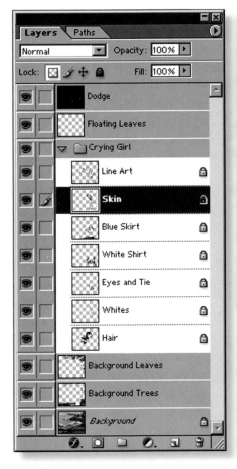

▲ **The Layers palette in Photoshop.**

▲ Many layers make up this image. There are six layers for the cel-style colour, three layers for the background, one adjustment layer, one layer for overlapping leaves, and one line art layer.

LAYERS TIPS AND HINTS

Creating a new layer

Click on the New Layer button on the Layers palette.

Rearranging layers

When created, layers are stacked on top of previous layers. To change the layer order, simply drag and drop the layers into the desired new position. To move the very bottom 'background' layer, you must first rename it to unlock it from its position.

Delete layers

Drag and drop the layer you want to be deleted into the wastebasket icon on the Layers palette.

Merging layers

- Merge Down: Combines the currently selected layer with the layer directly below it
- Merge Linked: Combines all linked layers
- Merge Visible: Combines all currently visible layers
- Flatten Image: Combines all layers

Duplicate layers

This enables you to experiment with your layers without directly affecting the original copy of the layer. To do this, right click on the layer you wish to duplicate, and choose Duplicate Layer.

▲ This diagram illustrates how layers come together to create an image.

5

DIGITAL INKING

Inking helps to give your artwork a clean, professional look. Inked lines are more definitive than pencil lines. There are many inking styles, all with different functions.

This chapter focuses on aspects of digital inking, such as setting up your tools, techniques, and styles, and how each corresponds to a particular mood and coloring style – and even using pencil art as your line art for coloring.

In manga-style artwork, inked lines are usually contour lines, denoting the outline of the characters, objects, and the most important details. For example, the line work of a character's hand would depict the outline of the fingers, but wouldn't show shading, wrinkles, or folds in the skin. It is up to the colours to show depth and texture.

It is possible to add definition through inking techniques such as hatching, stippling, and spotting blacks. These details are atypical in manga-style art, but can be employed for stylistic purposes to achieve a distinctive look.

The premise behind inking is simple – to make the lines as dark and precise as possible to contrast with the paper, so that the image reproduces better when scanned. Inking an image also gives a definitive guide to follow when colouring the line work.

The importance of clean line work cannot be stressed enough. Your drawing should be clear and easy to follow, so you'll be able to smoothly guide the Pen tool along the lines to create your finished inked piece. You shouldn't have to play a guessing game, trying to resolve which lines are necessary to the image and which are leftovers from the revision process.

DIGITAL INKING PREPARATION

The aim of digital inking is to create definitive lines with a high level of detail where there were previously only rough pencil lines.

THE PROCESS

The process involves drawing on the slick surface of a tablet with a plastic-tipped pen while looking up at your monitor rather than down at your paper. It'll take time for you to get comfortable with it, but can yield results well worth the time spent!

Clean, smooth lines, and high levels of detail can be achieved with digital inking. Paper size and resolution can be as large as you desire, and the Zoom tool can enlarge small sections of your image to fill the full size of your computer screen. From there, you can draw small, intricate details while still working big.

The increased image size can unfortunately make digital inking a time-consuming, awkward, and confusing process. There's more ground to cover, and more detail to add. Plus, working with an image that's several screens in length is like looking at a piece of paper through a magnifying glass. If your pencil lines are loose and open to interpretation, you may end up inking lines that you didn't intend to ink, or rendering objects out of proportion. With a little practice though, these negatives can be overcome.

SOFTWARE FOR DIGITAL INKING

Painter

Of the applications currently on the market that can be used for digital inking, Painter is without doubt the best suited. Using your graphics tablet in conjunction with Painter, you can do pretty much everything a traditional brush, nib, or technical pen is capable of. Painter has a wide variety of inking tools that can produce smooth, bold lines. The lines are anti-aliased, and change from thick to thin with just the slightest pressure from your stylus.

Photoshop

Photoshop is a great application for colouring and photo-editing, but isn't quite as good for inking. Photoshop was never designed with natural media tools in mind, so trying to simulate them within the program is tricky. The Paintbrush tool, with some tweaking, can create lines of decent quality. However, the lines are more jagged than lines created in Painter. Photoshop also lacks the Rotate tool, an important tool for inking.

Scratch-board tool · Leaky pen · Texture pen · Ballpoint

Tyre tracks · Speed lines · Hatching lines

▲ **Examples of different types of lines that can be created in Painter.**

▼ **Examples of different types of lines that can be created in Photoshop.**

Inking brush · Standard hard brush

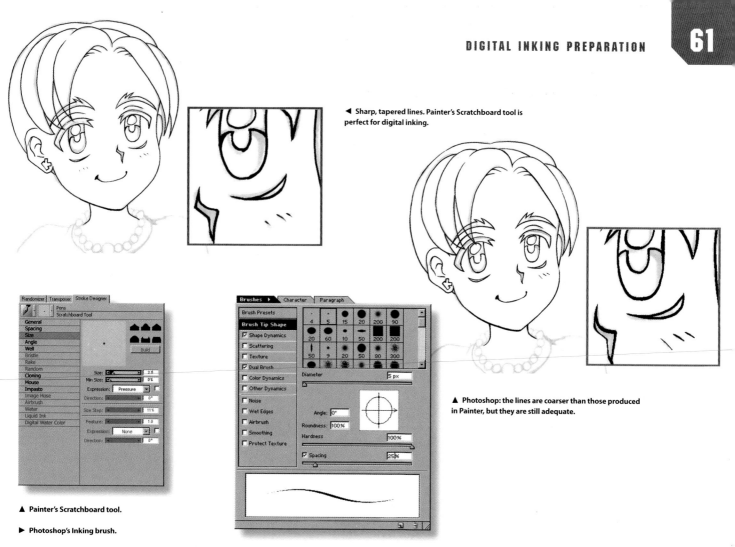

◄ **Sharp, tapered lines.** Painter's Scratchboard tool is perfect for digital inking.

▲ **Photoshop:** the lines are coarser than those produced in Painter, but they are still adequate.

▲ **Painter's Scratchboard tool.**

▶ **Photoshop's Inking brush.**

TOOL SETUP

SOFTWARE	**Painter** Scratchboard tool	**Photoshop** Inking brush
PROS AND CONS	The Scratchboard tool, located on the Brush palette, produces dark, bold, and crisp lines. This is the definitive tool for digital inking, after some tweaking. It can have as much grace and versatility as any nib or brush.	Prior to version 7, Photoshop allowed for very little brush customization. The best inking brush the program offered was significantly thicker and fuzzier than the Scratchboard-based inker in Painter. With the release of version 7, the increased flexibility of the Photoshop Brush palette made it possible to create an inking pen in Photoshop almost as good as those in Painter.
SETTINGS	Size 2.5 pixels, Minimum size: 0%	**Brush tip shape** Choose a hard, round brush, Diameter: 5 pixels, Angle: 0°, Roundness and hardness: 100%, Spacing: below 25%. **Shape Dynamics** Size control: Pen Pressure, Minimum Diameter: 1%, Other options set to 0% and off. **Dual Brush** Choose a hard, round brush, Mode: Color Burn, Diameter: 1 pixel, Spacing: 1%, Scatter: 0%, Count: 1.
TIPS	For detail work, decrease the pixel size. For filling in large areas with black or fuller strokes, increase the pixel size.	

▲ To make the inked line art easier to distinguish from the underlying pencil artwork, it's helpful to change the colour of the lines to blue.

BLUE LINES

When inking a picture, your sketch lines should be light enough to easily distinguish between them and your inked lines. Following in the tradition of non-photo blue pencils (which are used by comic inkers because they don't reproduce when printed), try changing the colour of your pencils to blue to make them easier to ink over.

Painter

Hit the N key on your keyboard to open up the ColorTalk menu. Input the following code, 'blue=1', by dragging and dropping from the list of words and symbols. When the information is entered, choose Save and give the operation a name such as 'Blue Lines'. This means that you'll be able to quickly run the action again by simply choosing Open and selecting 'Blue Lines' rather than dragging and dropping all of those input options. Hit OK to convert your lines to blue.

Photoshop

Choose Image>Adjustments>Hue/ Saturation. Check the Colorize box, set the lightness to around +20, and adjust the Hue and Saturation slider bar until the colour turns blue.

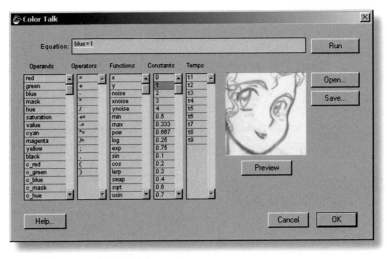

▲ In Painter, you can use the Color Talk menu to change the lines to blue.

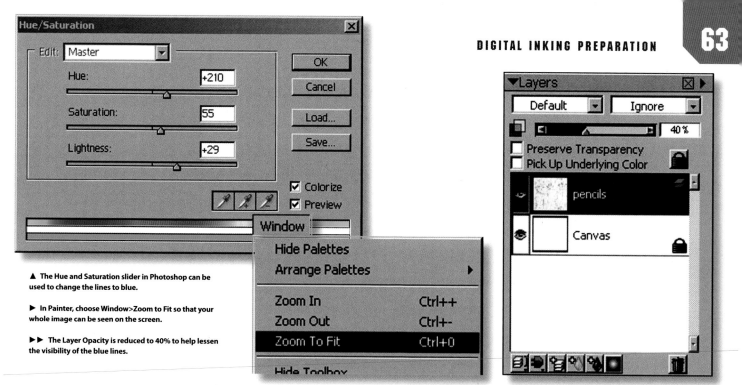

▲ The Hue and Saturation slider in Photoshop can be used to change the lines to blue.

▶ In Painter, choose Window>Zoom to Fit so that your whole image can be seen on the screen.

▶▶ The Layer Opacity is reduced to 40% to help lessen the visibility of the blue lines.

OPACITY

The lines are a nice shade of blue, but they're still too dark. The next step is to lower the opacity.

Painter

Choose Select>All, and then Edit>Cut. Next, Zoom to Fit by double-clicking on the hand icon to centre your image. Then, choose Edit>Paste. This will place your sketch on the new layer. You can move down the Opacity slider on this layer to dim the visibility of the lines (around 40% works well).

Photoshop

The same process works in Photoshop, minus the Zoom to Fit step.

GENERAL TIPS

● Create another new layer above the pencils layer to separate your inked lines from your pencils and title it 'inks'. The image is now completely set up for inking.

● Practise drawing smooth, tapered lines with varying pressure and weighting before jumping into inking your first drawing. Try going from thick to thin, increasing and decreasing pressure as you draw.

● Where you start inking on your image is up to you. I generally like to start working with the character's face and hair and then gradually move down the body to the feet. Remember, the amount of pressure you use will vary the line width. Be patient and keep your style as consistent as possible.

● Most of your image should be inked at 100% and 200% zoom to produce smooth, controlled lines. Remember that this will be your final draft, so don't rush. Put on the finishing details, line by line. Focus on all aspects of your drawing: give every part the same attention.

● Create lines that suggest shadow, motion, and form. Thicker lines help emphasize objects in the foreground, or suggest darker shadows on figures. Delicate features like eyelashes and flowing hair benefit from wispy, thin lines. Try using a thicker line for the contour outline of the character and thinner lines for inner details. Experiment, and be patient. Digital inking requires practice, persistence, and control.

DIGITAL INKING TECHNIQUES AND STYLES

How you choose to ink your image can be as important as the tools you use to ink your image. Colouring completes the image, but the inking outline holds the image together. As an artist, it's important to consider how the line work will affect your picture.

CHOOSING THE STYLE

Line consistency, width, placement of blacks, and hatching are just a few aspects of inking styles to consider. Some inking styles emphasize cuteness, others emphasize harsher aspects of reality.

Thin, uniform lines

Manga-style artwork in general, especially when using cel-style colouring, corresponds well with thin, uniform lines. These lines are noticeable but not overpowering. When the image is coloured, the thin lines complement the shading and create a balance. If the image forgoes colouring, however, these thin, technical lines can actually make the picture look too dull and uniform, giving the eye little to focus on.

Bold lines

Artwork with thick lines can look playful, cute, and attention-grabbing. If you're doing something cute or comical, or want the character to be the focus of the image, then you may want to consider bold lines. A good usage of bold lines would be for drawing SD characters.

▲ Bold lines. Inked using Scratchboard tool variant with the minimum size set at 40% and a size of 6px.

Thin lines inside, bold outer edge

Drawing a character with thin detailed inner lines and a bold outline can help make them the focal point of the picture.

Rough lines and cross-hatching

Cross-hatching lines can give an image a rougher, sketchier look. Good for artwork that favours grittiness or realism. Hatching provides a means of gradually darkening an area from white to black. If done with precision, the layering of lines can be as effective as screen tone. One drawback to rough hatching lines is that they make it difficult to make selections or fill areas with colour.

▲ Thin and thick lines. Inked with the Scratchboard tool set to 1.5px. The character's outline was inked with the same pen set to 5.5px.

◄ Thin lines. Inked using Scratchboard tool. Size 2.5px.

◄ Rough lines. Inked using Crowquil 3.0 pen (Painter 9) and short quick strokes.

◄ Weighted lines. Carefully inked using Scratchboard tool variant with a size of 6.5px. Straight lines were made with a 1.5px brush size and the 'straight line' brush option, and then inked over freehand for additional thickness.

▲ Spotting blacks. Inked using Scratchboard tool variant of varying thickness, 1.5px to 6.5px or greater, for filling large areas of black.

Weighted lines

Heavily utilized in comic art, these lines are bold in some areas and thin in others. They can help draw attention to a portion of the image or to show lighting effects (for example, a surface that's hit by light would have a thin outline and a surface in shadows would have a thick outline).

Line weighting can also play an important role in helping the viewer distinguish depth. Objects with thicker outlines appear to be more towards the foreground, while objects with little or no outlines seem to fade away in the distance.

Spotting blacks

This is the inking equivalent to having a person standing in a room of total darkness and then hitting one side of that person's body with a spotlight. Using striking contrast can give your image a dark, sinister feeling. In comic art, spotting your shadow areas with black can be quite effective.

Practical usage of spotting black includes any area that requires solid black such as eyelashes and eyebrows. However, if you plan on giving the character in your image red eyebrows, it doesn't make sense to fill the area with black – instead, just draw the outline.

Other styles

Be experimental, look at other artists' styles, and see how their inking affects the final image. For a well-balanced picture, consider combining several inking styles.

Remember that mismatching the inking style and the desired emotional impact of your picture can be disastrous. Try to use or develop a line art style that suits your artwork and your personal taste.

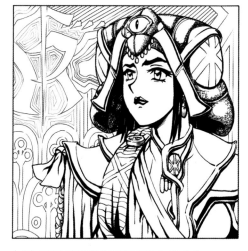

▲ Other styles. Inked with Scratchboard tool variant set to several different-sized settings. Stipple effects created with a Leaky Pen variant.

LINES AND SHAPES

One drawback to digital inking is that you won't have access to traditional tools like rulers, French curves, and triangles. Luckily, Painter is able to produce line shapes such as straight lines, circles, ellipses, and squares with perfect accuracy.

PRODUCING STRAIGHT LINES

Painter is easily capable of producing straight lines. You can switch from the normal freehand drawing style to the precision-straight lines style using the brush property bar or by pressing Shortcut Key V on the keyboard. To return to Freehand mode, press Shortcut Key B.

Once you've set your Draw Style to Straight Lines, click on your image at the point where you want the line to begin. The second place you click indicates the end of your line. As long as you don't unclick or lift the stylus, you can drag this line around, and thus change the ending point. Repeating the process will continue your line segment from the last point. Pressing Enter will close the set of lines by drawing a line from the last end point to the starting point of the line set. To start a new line segment that doesn't start at the end of the previous one, press V.

As you can see from the line samples, above, there are no tapered edges or varying line widths. Because of this, Painter's straight lines may require a pass over with a Freehand brush to get the results you desire.

▶ **The Shapes tool is located on Painter's Toolbox palette.**

▶▶ **Make a perfect circle by clicking and dragging.**

PRODUCING CIRCLES AND BOXES

The Shapes tool, located on the toolbox, will assist you in drawing basic shapes. Because the Shapes tool is vector-based, it doesn't work like the pens and brushes present in Painter. The default shape is the Rectangle tool, but clicking on it and holding down for a second will reveal the Oval tool.

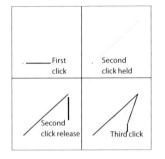

▲ **Creating straight lines in Painter.**

DRAWING YOUR SHAPES

Shapes are made by clicking on a starting point and dragging until the graphical representation reaches the desired size. Releasing the mouse button or lifting the stylus tells the program to draw the shape.

To make a perfect square or a perfect circle, hold down the Shift key before clicking and dragging the object.

If you look at the Layers menu, you'll see that creating a shape produces a new layer, title either called Rect #, or Oval #, depending on which type of shape you used. These layers are not yet made up of pixel data and may be further edited as vector objects.

MODIFYING YOUR SHAPES

To modify your shape's attributes, double-click on a shape selection layer to bring up the Set Shape Attributes menu. Unless you want a colour-filled shape, uncheck the Fill box, and check

▲ Your newly created shape will show up on the Layers menu as either a Rect1 or Oval1.

the Stroke box. Choose a line width that is appropriate for your image. If you wish to make these new settings default for all future shapes, click on the Set New Shape Attributes box.

To move a shape, select the appropriate layer, and then choose the Layer Adjuster tool. Click and drag the shape around like any other layer.

▲ Set Shape Attributes menu.

To increase or decrease the dimensions of a shape, first select the Layer Adjuster tool and then click and drag one of the eight points surrounding the shape.

MERGING YOUR SHAPES WITH THE INK LAYER

Once you've finished manipulating your shapes, you can group and collapse them with the inks later.

To merge your layers, click on your inks layer, and then hold down Shift and click on any of the shape layers you wish to

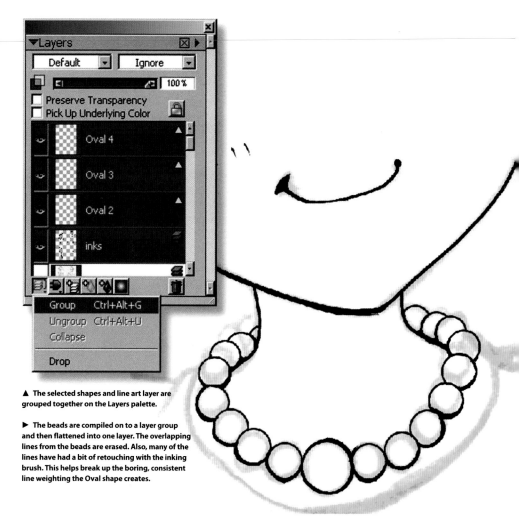

▲ The selected shapes and line art layer are grouped together on the Layers palette.

▶ The beads are compiled on to a layer group and then flattened into one layer. The overlapping lines from the beads are erased. Also, many of the lines have had a bit of retouching with the inking brush. This helps break up the boring, consistent line weighting the Oval shape creates.

combine. Once the layers you want to combine are highlighted, click on Group and then Collapse to merge the data into one layer.

Choose Commit All and the selected layers should finally be merged into one. Once this is done, you'll be able to erase and redraw segments of your shapes using the pens, brushes, and other tools.

USING PENCIL ART AS LINE ART

While inking can be an important part of the creative process, it isn't the only way to do things. There are no hard-and-fast rules – everything's open to experimentation and interpretation. In many, but certainly not all, of cases, inking makes sense. Here are some instances where you may not need to go to the trouble of inking your image.

PAINTING THE IMAGE

As paintings do not always contain distinct outlines, you do not have to ink your picture. Traditional painters often use soft pencil or charcoal lines to get a rough idea of where they plan to block in colours. The outline is only there as a guide, and is painted over as the work progresses. In the completed image, lines are non-existent. Why go to the trouble of inking lines if you're not going to see them? While the painted look works well with realistic backgrounds and objects, keep in mind that manga-style characters often suffer without discernible lines.

THE 'NO-LINE' LOOK

You're not painting, but you want the 'no-line' look. It can be difficult and time-consuming to make pictures where the characters and objects have no discernible outlines. These pictures rely solely on traditional painting techniques and colour theory to show an object's edge without actually drawing an edge on the object. Manga-style artwork is usually dependent on an outline. Without the outline, the picture can fall apart. This rule especially applies to the facial details. That's why it's important to have a defined outline, very careful colour placement, or a strong, traditional painting technique.

SHARP, CLEAN, DARK LINES

Your pencil lines are sharp, clean, and dark. If your pencil lines are a consistent black that's easy to scan and reproduce with minimal clean-up, you may be able to save yourself some time, and avoid the inking process. Just scan and work from your clean pencil lines.

ROUGH-LOOKING LINES

You want rough-looking pencil lines for stylistic purposes. Images with pencil lines can have interesting features when used with various digital colouring techniques, but rough lines make them harder to colour fill than inked lines.

▼ These pop star idols were built up using carefully placed flat colours, shadows, and highlights to draw out their features.

◄ There's really nothing inking can do for this picture, besides sharpening up some of the rough lines.

▼ Rough line art can have personality and charm, but if not executed with great care, may lack the polished feel of clean or inked line work.

◄ Besides a few facial details, there are practically no lines remaining in this image. Painting is extremely time-consuming compared to other digital art methods. Attention to lighting and precise colouring is required on painted images, but can have amazing results.

GENERAL TIPS

- Even if you're going for the stylistic charm of rough pencil lines, try to keep them as neat as possible. This will keep them from interfering with the colours in your work.

- Even when not inking, you can still create the thick-to-thin effect of tapered lines by varying pressure and layering pencil strokes.

- Pencil shading lends additional rough texture to your picture. One drawback is that it will muddy up colour work, giving it a dark or silver cast.

- Be sure to clean up extraneous lines, such as guidelines on a character's face, so that they disappear on the final picture.

- Make sure your lines are dark enough where you can see them, unless they are only intended as a guide.

DIGITAL COLOURING BASICS

Colour is a crucial element in manga-style artwork,because it helps to realistically depict a scene or character, and to provoke emotions in the viewer.

No matter which colouring style you pick for your drawing, you need a good understanding of how to properly utilize colour for the best effect.

The colouring process starts with basic know-how, such as how to fill your artwork with colour while retaining the beauty of the underlying line art. The process becomes quite complex as you search through an endless range of colours for the perfect shade. In manga-style artwork, there are countless possibilities. Understanding how to place shadows and highlights upon your colour combinations is equally important.

This chapter will introduce you to the tools, techniques, and skills you require to successfully colour your images and give your manga-style art a three-dimensional appearance.

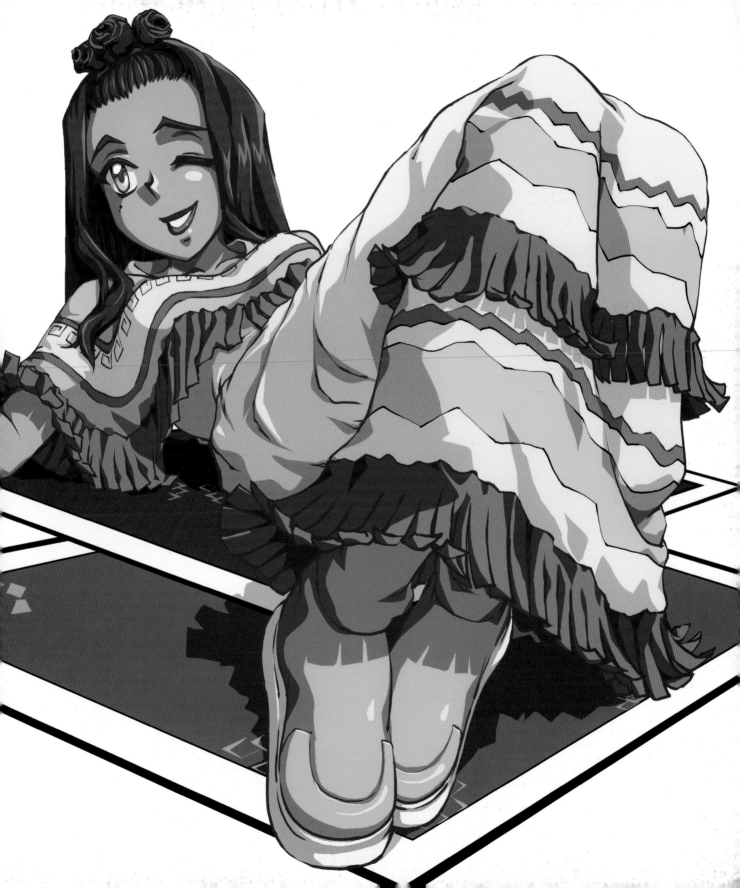

COLOUR FILLING

This section shows how to properly fill a picture with colours without destroying the line art. You'll want to start with clean, transparent line art as your topmost layer.

1 *This step isn't absolutely required, but I find that filling the background layer with a colour other than white helps make the character colours stand out better. This will help you figure out where you haven't filled colour in your picture, as the background colour will peek through in the areas where you've missed a spot. Choose a colour for your background layer that's contrasting, but not distracting. Make sure it's a colour that you won't be using much in your image (i.e. don't use blue if your character is wearing a blue dress).*

2 *To fill the background layer with the colour, choose Edit>Fill.*

3 *Next we select the areas we want to work in. Set your Magic Wand options to the following: tolerance: 30, anti-aliased, contiguous, use all layers. A tolerance of 30 is a good mid-range number that reaches the limit of the black lines without going over. A high (75 or higher) tolerance will select a large area, often going past the black lines, and a low tolerance (20 or lower) will select a small area, staying far within the black lines.*

It's a good idea to start with the skin, so create a new layer titled 'skin', and use the Magic Wand to select those areas on the picture. To continue adding more areas to the selection, hold down Shift on the keyboard.

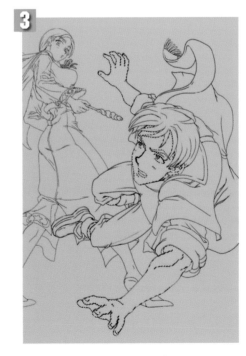

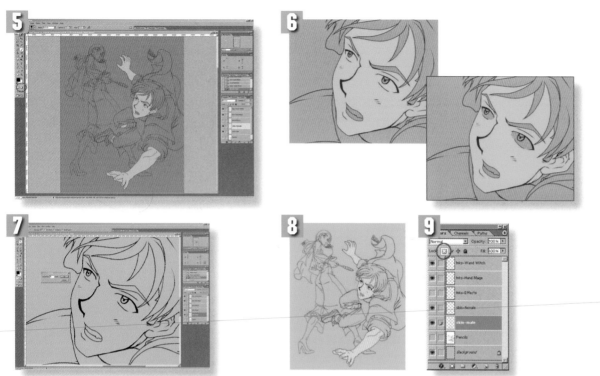

4 Gaps in the line art can make selection difficult. Use the Brush tool to close off the openings. First an opening in the line art allows outer areas to be selected. The gap is located, then the openings are sealed with the Brush tool. The woman's hand is selected without further difficulty.

5 To select the small, hard-to-reach areas, use Quick Mask Mode. To access Quick Mask Mode, click the Quick Mask button located in the lower right area of the Tool palette. Unselected (masked) areas will now be displayed in red.

Use the Hard Round Brush tool (set at 100% hardness, 100% opacity) to add or remove areas from the selection. Black adds to the red masked area, white removes.

6 Use the white Brush tool to remove the white portions of the eyes from the selection.

7 This ensures that the colour bleeds into the black line art – not enough to go past the lines, but enough to cover the entire section and prevent white edges. Choose Select>Expand. Expand your selection by 2 pixels (1 for thinner lines, 3+ for thicker lines).

8 Pick an appropriate colour for the selected areas and choose Edit>Fill.

9 On the Layers Palette, choose Lock Transparency (Preserve Transparency in previous versions of Photoshop) to confine colouring solely to the areas that have been filled with colour.

10 Repeat the entire process on the remaining colour layers.

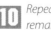

COLOUR CHOICE

In addition to knowing which colours correspond well with other colours, picking out appropriate shadow and highlight colours, or even the character's skin tone, can make an impact on the finished piece. This section covers which tools you can use to help you with these areas.

TOOLS

Color Picker menu

The Color Picker menu gives you access to a full range of colours. To bring up the Color Picker menu, double-click on the Foreground/Background Color box on the Tool palette. Slide the bar up and down the colour scale to find the appropriate colour family, and then choose a dark or light value of that colour.

Every colour imaginable is within your reach, so don't limit yourself, but also don't let the selection overwhelm you. Too much variety can lead to an overly gaudy and unappealing blend of colours in your images. Consider your colours carefully, and aim for balance and contrast.

Eyedropper tool

The Eyedropper tool enables you to lift colours from other images. You can use it to reproduce the colours of a character from a previously created image, or borrow inspiring colour schemes from other images and photos.

If you want to retain a palette of the colours that you choose for your picture, open up a new document, blot down your colours, and save the document. You'll be able to reselect these colours using the Eyedropper tool.

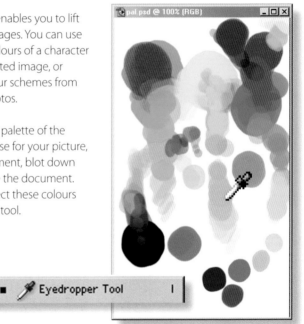

▲ Creating a custom palette containing all of the colours you need for a particular image helps save time and keep the colours consistent.

◀ Painter includes a handy Mixer palette that serves this very purpose.

◀ Use the Color Picker menu to access a vast range of colours, but be judicious with your selection.

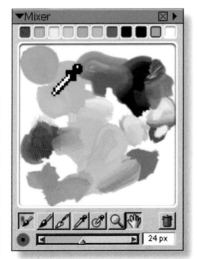

▲ Colour reference books, such as *The Designer's Guide to Color Combinations* by Leslie Cabarga, are a terrific resource for colour inspiration.

▲ Try experimenting with a variety of colours for your characters.

COLOUR REFERENCE BOOKS

Colour reference books that showcase striking and inspiring colour combinations can be very useful. These books often list colours by their RGB, CYMK, and hexadecimal code, which you can easily enter into Photoshop through the Color Picker menu.

SKIN COLOURS

Most characters have skin colours that stay within the red hues (from pink to brown), but depending on the character's race, gender, ethnicity, species, etc., you might want to try experimenting outside that range.

Ethnic traits

Many manga art styles simplify characters down to a triangle nose and big, expressive eyes set in a rounded, heart-shaped face. It's an exaggerated and very stylized caricature that often fails to suggest any sort of ethnic or racial background.

While colour serves as an indicator of racial background, adding facial details to the drawing can help emphasize ethnic traits.

Science-fiction and fantasy traits

In the case of fantasy or science-fiction artwork, the normal range of colours may be too confining for your tastes. Don't be afraid to give your characters unusual skin tones if that's what the image calls for.

Shadow and highlight colours

For best effect, your shadow and highlight colours should differ from the base colour tone enough for significant contrast. The highlight should be lighter than your base colour (either white, a lighter version of the base skin tone, or an entirely different colour related to the light source), and the shadow should be darker. A good contrast between the first tone and the second tone gives the character more depth. Very little difference between tones can make your characters look two-dimensional.

▶ This shows only a few of the countless base, shadow, and highlight combinations.

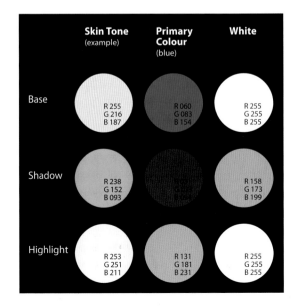

	Skin Tone (example)	Primary Colour (blue)	White
Base	R 255 G 216 B 187	R 060 G 083 B 154	R 255 G 255 B 255
Shadow	R 238 G 152 B 093		R 158 G 173 B 199
Highlight	R 253 G 251 B 211	R 131 G 181 B 231	R 255 G 255 B 255

COLOR PLANNING AND CORRECTIONS

Experiment with different color choices before jumping into the colouring process. This is especially true if you're planning to paint, watercolour, or airbrush the image, as there is no easy way to tweak the colours once complete, although if you do want to adjust your colours later, you can use Photoshop's Hue and Saturation.

PRELIMINARY PLANNING

Colour planning gives you a wonderful opportunity to test out different colour schemes, discover which colours correspond best with each other, and help set the desired mood for the image.

To quickly cover a lot of ground, zoom out and work with larger-sized brushes. Don't worry about staying within the lines or adding small details. Colour planning can be as rough and sketchy as you like, but while it can be extremely helpful, try not to spend too long on it. It isn't your final piece, so it doesn't need to be polished.

Once done, save a backup copy of the image in the JPG file format (as well as PSD if you're not worried about space), and then try again with another set of colours. Don't be afraid to try a couple of different colouring schemes before deciding on the one you like the most. The JPG copy you saved of your colour composition is small enough in file size to open alongside your actual piece without slowing down the system. You can use the Eyedropper tool to grab colours from this colour sketch for use in the real version.

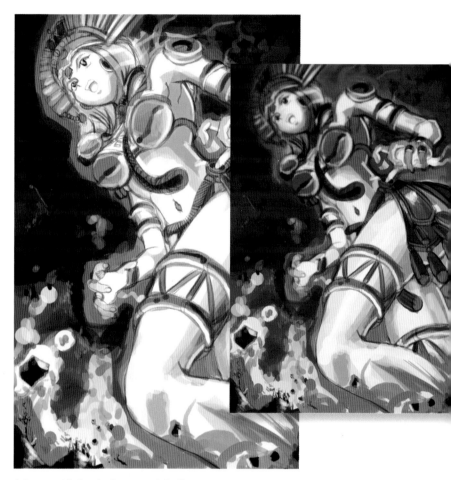

▲ Two potential colour sketches were made for this sun goddess illustration. To effectively depict her illuminated form, reference images of magma, suns, and bonfires were acquired and studied.

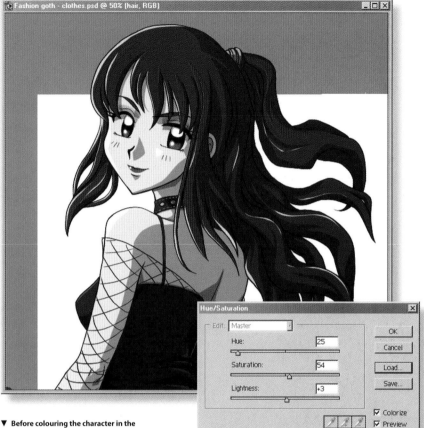

▲ ▶ The girl's hair colour is easily changed from purple to red through the use of the Hue/Saturation window in Photoshop.

HUE AND SATURATION

Once the picture is complete, sections can be re-coloured using Hue and Saturation. For example, let's say you don't like the character's hair colour. To change the colour, the hair is carefully selected using the Lasso tool so that you don't accidentally change the colours of other objects on the same layer. Then choose Image>Adjust>Hue/Saturation to bring up the Hue/Saturation window.

Adjusting the slider on the three sets of bars changes the colour. Hue will change the colour of the hair from green to blue to red, and everything in-between. Saturation will change the level of saturation, from bright, highly saturated colours to dull, grey colours. Lightness will adjust the darkness or lightness of the colour. The Hue/Saturation menu is a great way to experiment with a variety of colours, especially if you're unsure which colour you want to use for a particular area of your character. The colours change in real time, so you'll be able to preview the colour changes on your character as they're being made. Once you've got a new colour that you like, just hit OK, and you're done!

▼ Before colouring the character in the complicated crab armor, a quick colour plan was in order. While I was happy with the general scheme worked out in the plan, I decided to remove the busy fabric pattern on the back of the cape. I felt it competed too much with the skirt. Knowing this ahead of time cut down hours of time when working on the final cel-style image.

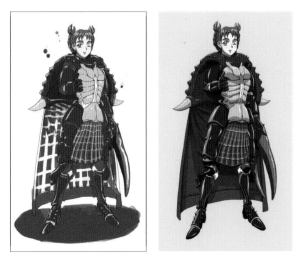

INTRODUCTION TO SHADOWS AND HIGHLIGHTS

Shadows and highlights play a crucial role in defining form by giving a two-dimensional image a three-dimensional appearance. A good drawing should already begin to suggest depth through line weight and shape, but colour serves to reinforce the illusion of depth. This section discusses how shadows and highlights work.

SHADOWS AND HIGHLIGHTS

When light hits a solid object, the light is absorbed. Since light is unable to reach the area covered by this object, the area falls into shadow. The exact shape and intensity of the shadow changes depending on the circumstances; for instance, the direction and the location of the light causes the shadows to become long or short.

Shadows

Shadows are depicted as a much darker shade of the base tone and represent an absence of light. There are some general rules you should follow when placing shadows, as follows:

- When dealing with a single light source, shadows cast by all objects in an image should travel in the same direction.
- Light generally comes from above, except in specific circumstances (like a flashlight from below).
- The shadow will be on the opposite side of where the light hits the object. If the object curves inwards however, the shadow will be on the side closest to the light.

Highlights

A highlight is a concentration of light or a reflected light source. It is depicted as a much lighter shade of the base tone, and represents points of the object closest to the light source.

The shape of the highlight depends both on the light source, and the shape of the object the highlight is placed on. Highlights tend to repeat the external contours of the object. They're circular on rounded objects, such as cheeks and shoulders, and long and tapered on tubular objects, such as arms and legs.

A portion of the highlight can be thickened to denote the section closest to the light source. Tapering the highlight until it gradually disappears can suggest an area where the highlight becomes less intense and diminished.

CONSISTENT LIGHTING

Although you'll be colouring your image in sections, moving from skin to hair to clothing, try to think about your image as a whole. It is possible to use some artistic licence with your shading, and still turn out a good image. However, inconsistent or seemingly random shading will serve as more of a distraction than an enhancement.

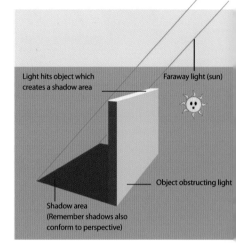

Light hits object which creates a shadow area

Faraway light (sun)

Object obstructing light

Shadow area
(Remember shadows also conform to perspective)

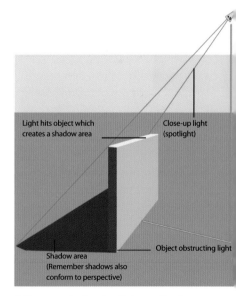

Light hits object which creates a shadow area

Close-up light (spotlight)

Object obstructing light

Shadow area
(Remember shadows also conform to perspective)

▲ These examples shows how the type and location of the light source affects the placement of shadows and highlights.

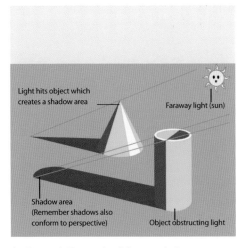

Light hits object which creates a shadow area

Faraway light (sun)

Shadow area (Remember shadows also conform to perspective)

Object obstructing light

▲ **This example illustrates how light creates shadows and highlights.**

▶ **Because the light source comes from behind in this illustration, the girl's front side is cloaked in shadows.**

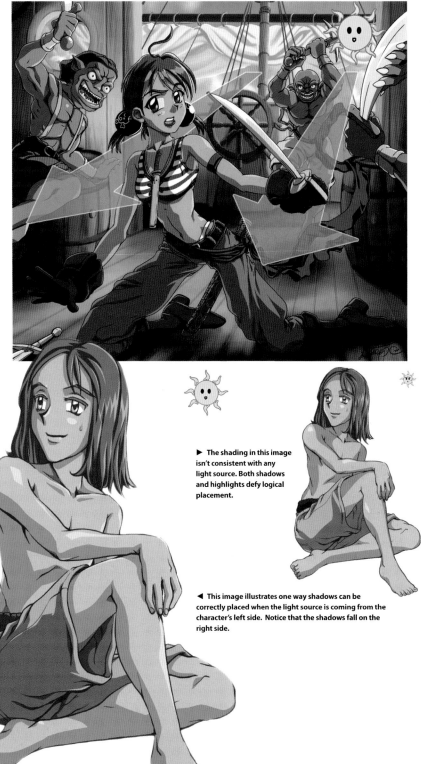

SITUATIONAL LIGHTING

Don't fall back on the same lighting scheme for all your images. It's easy to adhere to one generic location for placing shadows and highlights, but what if you're colouring an image where the character is standing in the foreground, and the light source is coming from behind? Think judiciously about where you need to place your shadows in order to make your character properly three-dimensional.

▶ **The shading in this image isn't consistent with any light source. Both shadows and highlights defy logical placement.**

◀ **This image illustrates one way shadows can be correctly placed when the light source is coming from the character's left side. Notice that the shadows fall on the right side.**

SHADOW AND HIGHLIGHT PLACEMENT

In traditional art, it helps to have a foundation in perspective and lighting to help guide your positioning of shadow and highlight in your image creation. If you don't have a strong background in art, don't worry! Practice makes perfect. Observe how light affects objects in real life, and apply this knowledge to your images.

GETTING IT RIGHT

It's simple to just apply a shadow here or there without putting any thought into it, but the trick is to place it correctly so that it makes sense and looks right. Take a moment to decide where the light is coming from. Imagine the whole object as a three-dimensional figure, and where the shadows and highlights might fall upon the object. If your character is in a room, is the light coming from the ceiling? A lamp, or candle on a table? What side of the character is the light hitting? Work out where the light will be hitting your character the strongest, and those areas where the light doesn't extend.

When applying highlights and shadows, take the curvature of the face and body into consideration. A shadow can indicate a change in the plane, or an area where the light doesn't reach, such as behind the nose, or the curve of the face, or a bend in an arm or finger. A highlight can suggest portions of the figure that are on a higher elevation and closer to the light source – the tip of the nose, the centre of the cheek, the top of the shoulder, or the thigh.

The face is not a flat object. Studying your own face will reveal many undulations. Notice how the nose and lips protrude, and how skin forms over the underlying structure of tissue.

Although the shading on an anime character's face is very stylized and heavily simplified, it still helps to keep in mind a sense of anatomy.

If you find yourself stuck while colouring a picture, unable to decipher where that next shadow or highlight should be placed, try using yourself or another person as a model. Find a strong light (natural or artificial, whichever is easier to set up for the situation), and shine it on the model as the light would shine on the character in your picture. Observe where the light hits the body and where the shadows are, and then reflect this in your image.

Finally, don't forget that placing shadows and highlights is an important part of an artist's style. These stylistic choices are especially noticeable on the hair and face, but are also apparent on other parts of the character as well. Study how other artists place shadows and highlights on their characters, and then work to develop your own individual style. When studying other artists' work, ask yourself the following:

- Where on the body do they place shadows and highlights?
- How are the shadows and highlights shaped?
- What colours are used for the shadows and highlights?
- How do they use dark and light to accent muscles and other features?
- Do the shadows and highlights have jagged or smooth edges?
- What sort of effect are they trying to achieve?

▶ The colour of the shadows and base tones can set a scene, or place your character in an environment, even with minimal scenery. In this case, pale, desaturated base tones and blue shadows tell us that the character is out on a moonlit night. Since the light is dim, highlights are mostly cosmetic and kept to a minimum. As would be natural for this scene, the light is coming from above, and in this case from the left of the characters.

▶▶ Eerie, upcast lighting goes a long way to emphasizing the impact of this image and underscore its place in the horror genre.

DIGITAL COLOURING BASICS

SHADOW AND HIGHLIGHT REFERENCE GUIDE

This reference guide shows how common light sources affect the human figure from different angles. Although the drawing itself should suggest depth and shape, one-tone colouring can make a character look two-dimensional, flat, and incomplete. Shadows and highlights help define the shape of the character.

REALISTIC LIGHTING

On the topic of realistic lighting, sometimes – and this is especially true for cel-style artwork (where lights and darks are heavily simplified) – a correctly placed shadow or highlight can look bad. At other times, an incorrectly placed shadow or highlight may look impressive. As a general rule of thumb, if it looks bad, omit it, and if it looks good or serves a purpose, go with it. For example, it might look good to put highlights on a strand of hair to suggest movement or shape even though the light may not actually be hitting it.

If possible though, stick with realistic shadows. Realistic lighting helps gives objects depth, and if you add a shadow or omit a shadow when you really shouldn't, your object might lose its sense of depth and look flat.

LIGHTING ANGLES

If you're puzzled about shadow placement for a particular area, find a strong light source – a flashlight, for example – and shine it on yourself as the light would shine on the character in your picture while looking in the mirror. Observe where the light hits your body, and where the shadows reside, and reflect this in your picture. If your character is in a room, is the light coming from the ceiling? What side of the character is the light hitting? Work out where the light will be hitting your

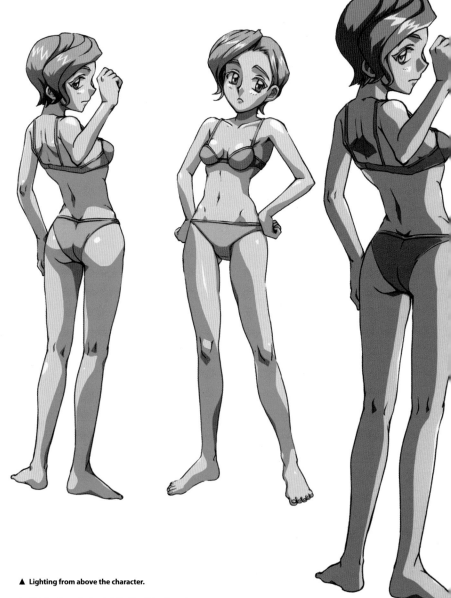

▲ Lighting from above the character.

▶ Lighting from the front right side of the character.

◄ **Lighting from behind the character.**

character the strongest, and where the light won't shine at all. Only experience will tell you what works and doesn't work, and a good foundation in realistic lighting is a good starting point.

Lighting from the front side

This is a commonly used light source, where the light source hits the character from either the left or right side. In this image, the light source comes from the right. Shadows reside on the left side of the character, highlights towards the right, emphasizing the three-dimensional qualities of the character's form. The character's face is brightly lit, with minimal shadows. Meanwhile, since the light source is coming from the front, the character's back is heavily covered in shadow. Areas such as the neck, under the arms, and between the shoulder blades receive an additional layer of shadow.

Lighting from above

This is similar to the first example, with subtle differences. With the light source directly above, the characters are evenly lit on both the front and back. The shadows fall on the underside of the figure, particularly below the head, on the legs, and on the underside of the arms.

Lighting from behind

The front of the character is comprised entirely of edge light. Edge light is a type of highlight placed on the edge of an object to help enhance the three-dimensional qualities of the character's form and is especially effective when used with intense shadows. The edge light helps show that a strong light is being cast at the character from behind. The back figure has shadows on the underside areas of the body, and highlights in key areas.

SITUATIONAL LIGHTING

In addition to the standard rules of shadows and highlights, your images may call for more advanced shading techniques. This section details some of the more complicated situations you may run into with your coloured works.

ADVANCED SHADING EFFECTS

Overlapping objects and multiple characters make shadow placement trickier, as each affects how shadows are cast upon the other. Trees, with their dense foliage, block off sunlight and cast an interesting leaf pattern upon the characters beneath. Shading subjects that are shown underwater must take into account the inevitable distortion. Finally, coloured lights can dramatically change all of the character's colours, especially the highlights and shadows.

MULTIPLE OBJECTS AND MULTIPLE CHARACTER INTERACTION

Realistic lighting should be consistent with all the objects in the picture. If there is more than one character in the picture, keep the lighting consistent on all of them. If two characters are facing the same direction, their faces towards the light, then the back of their heads should be shrouded in darkness unless there is a secondary light. Shadows shouldn't be randomly placed on objects. Your lighting must make sense.

If one object is overlapping another object, a shadow from the first object might be covering the second object. Don't treat each character in your picture as a separate image; the light interacts with all of the objects and the location of the objects will affect each other.

If the lighting is just right, an additional shadow can be produced on a character when another character is positioned close by. Keep this sort of interaction in mind when colouring multiple character pictures. When you place shadows, consider how the placement of one character may affect other characters in the image.

LIGHTING TREES

When a character stands beneath the protection of a tree, there's an opportunity to play with a really different type of lighting. This is a circumstance where showing the shape of the figure is less of a priority than the situation. Try adding some dappled, uneven highlights to any characters standing beneath the trees to portray sunlight breaking through the mass of leaves and branches.

UNDERWATER LIGHTING

Underwater lighting can be tricky. As light is scattered by material in the water and the breaking wave action at the surface, highlights and shadows ripple across objects mimicking the dancing waves at the surface. This can create an odd play of lighting rippling in every which way across the surface of an object. Whether in stormy seas or a calm pool, light filters down losing luminance as it travels. The deeper the area, the less light reaches it and the less you need worry about rippling surface waves. Water itself absorbs much of the visible spectrum, leaving the environment blue or blue-green. The diffusion of light in water tends to soften objects, or make them almost disappear. This becomes more important, depending on the depth of the scene.

◄ The mermaid pictured here isn't far below the surface. Light cast by the waves sends jagged highlights across the illuminated surfaces of the body.

▲ In 'Nature's Struggle' the tree women each struggle to be bathed in the precious light of the sun. The weaker of the two is covered in the shadows of her competitor.

Most important in an underwater scene is convincing lighting. A character saturated in appropriately coloured lighting above the surface won't be convincing beneath the waves. To grasp how objects look underwater, go to an aquarium, or hop in a pool. It's paramount to retain atmosphere in order to make the character look as though they are actually under water.

COLOURED LIGHTING

Lighting can greatly affect your character's colour scheme. An object's colour depends on both pigment and the properties of the light hitting it. For example, if your character is being hit with a red spotlight, try using lighter and darker shades of red for your highlights and shadows. Sometimes, you may not even want to use a highlight colour, depending on the object.

▶ The dense foliage casts a flickering variance of light and shadow over the girl's face. The light and shadows are placed where the light shines through the gaps between the leaves. As you can see, the shadows do a better job of showing the tree above the character than the shape of the character's face. You can almost get a feel for the location and shape of the tree without even seeing it by just looking at how the shadow falls across her face.

▲ Some objects, such as cotton clothing, will not reflect light well, and thus do not need highlights.

▲ In this much more dramatic example, the character has a single, intense red light shining on him. In the absence of all other light, the entire colour scheme shifts towards monochromatic red.

▲ If the character is in a room with some natural light but is placed under a red spotlight, his or her skin colour will have a red hue.

▲ This example shows the effects of radiant light. The character is placed in a red room and hit with an intense white light. This creates strong highlights and shadow areas. A small amount of red light is radiated back from the walls. This light hits the character and tints some of the shadows towards red.

USING COLOURS AS VISUAL METAPHORS

Colour choice is an often overlooked aspect of character design. All aspects of colour choice conspire to create an initial impression. Superficially, colours help the characters stand apart from one another, but on a deeper level, colour choice can be used to tell us something about each character's personality.

Anime and manga fans have become quite accustomed to unusual colours for characters' hair, eyes, and even skin tone. It's the accepted norm, thus allowing the artist to break from convention and use broad-ranging and unnatural colours even when depicting scenes from modern day life.

COLOURS TO EVOKE EMOTION

In these examples, the characters are given neutral expressions. This way, emphasis is placed on colour as the indication of the characters' personalities.

▲ Different colour combinations evoke different responses.

Angry colours

Despite her neutral expression, the red-and-dark brown colour scheme of the character pictured below shows underlying tension, as if the character were trying to repress anger or could snap.

◄ This character's colour scheme suggests tension.

Cool colours

Cool, blue-grey shadows along with blue eyes and grey-white hair give the character (*facing opposite top*) statuesque grandeur, almost as if he were carved out of marble and then brought to life. These subdued colours create a calm, wise, and reflective feel to the character.

Warm colours

The character above sports bright orange eyes, warm, golden-brown skin and hair, and glossed yellow lips. The festive, highly saturated colours exude warmth and a playful outgoingness. Her expression almost demands to be changed to a fun-loving smile.

To show how important colours are in perception, the same character (*above*) is shown with two different colour schemes. The mix of moderately bright greens and blues depict a character who looks much more compassionate and shy.

SKIN TONES

In addition to facial expressions, posture, hairstyle, and dress, the personalities of your characters can be hinted at with their skin colours. For example, a shy character might be depicted with pale skin; an athletic character, suntanned. For a natural look, try to give each of your characters a realistic but notably different skin tone. Variations in skin tone can make for a more colourful and interesting picture, especially if there's a lot of skin to be shown off.

▲ Cool color combinations evoke calm and trust.

▲ A full range of tones makes for a more colorful picture, and hints at the characters' personalities.

The following list of examples is by no means the only formula you should follow when assigning a skin colour to your character. This system should provide you with a good starting point, but remember that you're working from stereotypes, so be careful not to rely upon it too heavily. A withdrawn character is just as capable of having suntanned skin as the outgoing character. Use your judgment, and choose the skin colour that you feel works best for your characters.

Average flesh tone
This flesh tone would suit an average, everyday character with healthy skin, few unusual quirks in their personality, and no reason for either too light or too dark a skin tone.

Suntanned or dark flesh tone
Tanned skin seems to suit a tough character that gets him/herself into a lot of fights. Likewise, an athletic character might play a lot of outdoor sports, as extended exposure to the sun would result in suntanned skin. As tanned skin suggests masculinity; male characters and tomboyish or masculine girls can also benefit from darker skin tones.

Pale flesh tone
A shy or withdrawn character would generally stay indoors. Lack of sunlight would render their skin pale and delicate. Gentle, feminine characters often have softer skin tones.

Pink, fleshy skin tone
This would work well with pampered princesses and princes, healthy characters, children, and bouncy, playful characters.

Ghost-white skin
Good for weak and sickly characters.

DRAMATIC EFFECTS
Inconsistent lighting can be used for a dramatic or aesthetic effect. An example of this would be a man's face covered in shadows while all the other characters in the image are clearly visible. Although inconsistent with the rest of the picture, the shadows on the man's face help achieve a desired effect: they hide the man's true identity and make him seem more mysterious.

▶ (Clockwise from left) Although not consistent with the light source, the jagged shadow placed in the middle of this girl's face makes her expression much more dramatic. The gradient on the girl's face ignores the light source in favor of emphasizing her feelings of surprise and dread.

7

CEL-STYLE COLOURING

Traditionally hand-painted on a sheet of transparent celluloid acetate (from which the term cel is derived) with acrylic paint, cel artwork is the most time-efficient way to produce colour artwork for animation.

Many people colour cel-style artwork because it has a uniquely 'anime' feel to it. Unlike most Western cartoons, which place the focus on fluidity of the animation and flat-tone colours, Japanese animation focuses on detailed cel work. In anime, it's not unusual for a cel to have up to five separate tones of colour to designate highlights and shadows. This multi-tone shading helps create the illusion of depth in a 2D image.

Cel-style colouring differs from other styles, such as airbrushing and painting, because of the way the colours are separated into sharp divisions of shadow and light, rather than gradually blended.

Digital cel-style colouring strives to recreate the appearance of a traditional animation cel. Although the process is often less time-consuming than painting or airbrushing, it also requires a good understanding of colour and shading.

Adobe Photoshop is the application of choice for creating cel artwork on the computer. It contains all the necessary tools required for producing high-quality artwork that achieves the look of a traditional animation cel.

CEL ART PREPARATION

The sharp colour divisions of digital cel-style art can be accomplished through the use of the Freeform Pen tool. This section will show you how to properly set up and use the tool to make cel art images of your own.

For best results, the line art you plan on cel colouring should be inked and transparent. With your line art as your topmost layer, divide the areas of your image into separate layers and fill them with your desired colours. Once you're finished filling in colours, be sure to check the Preserve Transparency box on each layer.

Before you begin adding depth to your picture, take a moment to deduce the location of the light source, and where the shadows and highlights should be placed.

Although it's important that your shadows and highlights make sense and stay consistent throughout the picture, remember that perfect realism is not always necessary in cel colouring. In some cases, you may need to trust your instincts and do what looks best, even if it's not correct.

TOOLS

Color palette
As you work through each section of your picture, it's helpful to have both your shadow and base tone set up on your Color palette. Eyedrop the base colour off your picture, and set this as your first colour.

For your second colour, create an appropriate shadow colour. You'll mostly be working with the darker shadow tone while applying shadows, but having the base colour selected will allow you to quickly switch colours and easily paint over any mistakes.

Freeform Pen tool
Capable of achieving the precise colour separations required in cel artwork, the Freeform Pen tool allows you to freely draw a path around a section that you wish to fill with colour.

The Freeform Pen tool is located on the Tool palette. Click and hold down the Pen tool icon on the palette, and choose the icon off the expandable menu that shows a pen drawing a curved line.

▶ **The Freeform Pen tool can be found in the Tool palette.**

▼ **Use the Color Picker to select your colour.**

▲ **In preparation for cel art colouring, the picture is filled with the base colours.**

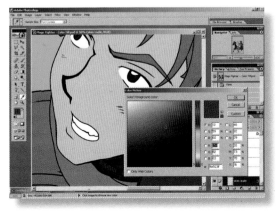

Freeform Pen Options

Curve Fit: 3 px

☐ Magnetic

Width:

Contrast:

Frequency:

☐ Pen Pressure

▲ Set your Curve Fit in the Freeform Pen Options.

► Using the Pen tool.

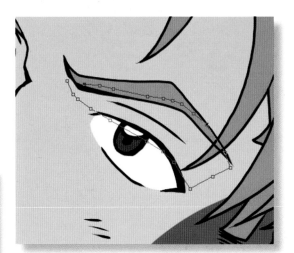

▲ Use the Brush tool sparingly.

It smoothes out your lines as you work, so the edges of your colours will rarely be jagged or choppy. Set to a Curve Fit of two pixels for small areas, or three pixels for large areas. A larger number of pixels will increasingly smooth your lines, but try not to go above four pixels or your lines will start curving to such a degree that they don't retain their original shape.

1 *Using the Freeform Pen tool, carefully draw an outline around the area where you want to add a shadow. You don't have to select all the shadow areas for a particular layer in one single pass. It's best to do one small section at a time so that if you make an error, you'll be able to undo the single mistake rather than the whole path.*

2 *Once you've drawn your path, fill it with the shadow colour by clicking on the Fill Path button on the Paths palette.*

3 *To create another path, deselect your current work path. Continue drawing, filling, and deselecting to add in all of your shadow and highlight areas.*

Pen tool

For more precision, the Pen tool allows you to point and click to specify the points of your path. You can later tweak these nodes to correct any errors. This process takes longer than the Freeform Pen tool does, but offers more control.

Brush tool

The Brush tool is useful for refining and filling areas that are difficult to select with the Pen tool. Use sparingly, though, as the Brush tool tends to result in clumpy blobs of colour.

STEP-BY-STEP CEL ART

The cel art style derives from traditional animation. Cel-style colouring is the quickest method of colouring line work because it breaks up light and shadow into distinct areas, removing any gradation and unnecessary play of colours. It does, however, require skill and a good knowledge of how light and shadows work.

1 *Start by opening the image in Photoshop. Divide each area of the image into separate, easily workable layers and fill them with colour. Be sure to lock the transparency on each layer to preserve the transparent areas.*

2 *Before jumping right into adding shadows and highlights, take a moment to decide on the direction that the light is coming from. For complex pictures with numerous characters and multiple lighting sources, a quick colour sketch can prove indispensable. After deciding on light sources, use a neutral colour to add shadows on a layer set to Multiply above the colour layers. Then add the adjustment layers and lighting effects until you have something you like.*

3 *Using the colour 'road map' as a guide, add the cel art colours section by section, one character at a time. I begin with the foreground character's skin. It doesn't matter which area you start with, but I prefer the skin because its smooth surface consists of multiple colour tones. This provides a good foundation for determining how light should be cast upon the rest of the character. After choosing a shadow colour, use the Freeform Path tool to draw and fill in the shadow areas on the skin.*

4

5

6

7

4 Once the initial shadows have been placed, you can opt to add an additional layer of shadows and highlights to add depth. Try not to go overboard – only add these colours to areas that are heavily shadowed or brightly lit, and only in small amounts. If you add too much, it loses the cel-style look, and clutters the picture. Add darker shadows under the character's chin, arm, skirt, and hair. Since, here, the character is heavily covered in intense shadows, a small dab of white on the lip is the only highlight required.

5 Add two shadow colours to her hair, drawn in jagged shapes to add volume to each strand of hair.

6 To give the pink portions of the outfit a shiny vinyl look, add two sharply contrasting shadow colours. Place white highlights on the portions closest to the light source.

7 Repeat the process of adding shadows and highlights for each of the remaining sections, taking into consideration the shape, location, and texture of the subject. Colours in this picture range from two-tone (base and shadow) to four-tone shading (base, shadow, darker shadow, and highlight). For example, to give the metal work its characteristic metallic shine, use four-tone shading; while for the soft fur, simple jagged two-tone shading is best. The man's cotton shirt doesn't reflect light; so you require only two-tone shading.

8 Now the cel art is complete, but still more can be done to the image. Meticulously working through the entire image, dodges, burns, coloured lines, gradients, and layer effects can be employed to add a magical, glowing quality to the image. If you compare the previous image and the final version, you will clearly see how background art and lighting effects can substantially increase the visual impact.

8

CEL ART IN DETAIL

Once you have had a go at achieving basic cel art, you are ready to take things one step further. This section looks at how to produce more detailed cel art colouring, from parts of the body to the different textures of your character's clothing.

SKIN

1 *To achieve a full range of depth, use four-tone shading (base, shadow, darker shadow, highlight) on the skin. First fill the skin layer with a base colour, and lock it to prevent colouring outside the lines.*

2 *Starting with my shadow tone, use the Freeform Path tool to draw an outline around the first area where you want to add a shadow, and fill it with your specified colour. Repeat the process for the rest of the shadow areas.*

3 *Then add an additional layer of darker shadow in small quantities to areas that require heavier shadows, such as in the crease of the character's brow, under the neck, within the inner ear, and beneath the nose. Finally, add yellow highlights to reflect the colours of the fiery night sky in the background. As with the darker shadow colour, try not to go overboard with the highlights. The edge of the face, bridge of the nose, cheek, and lip are common highlight locations.*

EYES

Because the eyes are often the most captivating part of a picture, they are naturally a large part of an artist's style. Quite often, the artist can be identified just from the style of the character's eyes. There are many different ways to colour the eyes, and the following method is by no means the only way to do it. Using this as a starting point, work toward developing your own style for colouring eyes.

1 *Since this scene features minimal lighting, change the whites of the character's eyes to a duller grey colour.*

2 *Add highlights where the light is reflected in the character's eyes.*

3 *Apply a darker grey shadow beneath the upper eyelid.*

4 *Add a hint of dark blue shadow around the edges of the highlight in the eyes.*

5 *Select a purple shadow to contrast the character's green eyes, and apply it around the pupil and outer edges of the eye. Keep in mind that a darker shade of green would also be appropriate. Experiment with assorted colours for varying effects.*

6 *The pupil is generally coloured black, but in this case, use a darker purple.*

7 *Make several passes with the Burn tool to create a vibrantly coloured highlight.*

8 *Using a lighter green colour, produced by the Burn tool, use the Eyedropper tool to draw along the underside of the pupil.*

9 *Place an additional white highlight beside the larger highlight, to complete the eyes.*

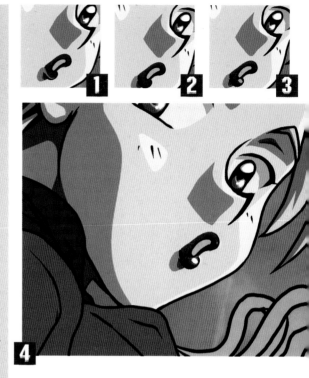

LIPS

1 *Colouring lips is a deceptively simple process, and can be quite fun once you get the hang of it. Start by choosing a flesh tone or lipstick colour that complements the character (I've chosen ruby red to match the woman's red coat).*

2 *Suggest depth and form by adding a darker shadow colour to both the bottom of the upper and lower lip. If the lips are closed, filling the entire upper lip with shadow is an effective technique for making the lower lip more pronounced.*

3 *Apply a circular highlight to the lower lip to make the lips look glossy.*

4 *Accentuate the highlight further by using the Dodge tool.*

HAIR

1 As with the skin, apply four-tone shading (base, shadow, darker shadow, highlight) to the hair.

2 After the base tone is placed, add a first layer of shadows. Unlike the skin, which is done in smooth separations of colour, the shadows on the hair must be jagged. Depending on your character's hairstyle, you may need to consider a variety of things. If the hair is drawn with distinctive strands of hair, you may want to individually add shadows and highlights to every single separation. If the hair is drawn as a single, large mass, you may want to colour it according to its shape. This character's hair is a mixture of both, so add shadows to each individual section, and then add a large shadow to the rest of his hair according to its shape and how the light hits it.

3 Add darker shadows where heavier shadows are required.

4 Sometimes highlights are jagged or curved, but in this case, add only a simple sliver of highlight to the edges of the hair.

COTTON CLOTHING

1 How you go about colouring your character's clothing will depend on the kind of clothing. For example, cotton cloth is a lustreless fabric, so it wouldn't get a highlight. Two- and three-tone (base and shadow) shading is usually enough, as is the case for these beige trousers.

2 Paying close attention to where all the previous shadows and highlights were placed, shadows and darker shadows are added to the creases and shadowed areas of the trousers.

VINYL CLOTHING

1 *Starting with the red base tone, shade the character's coat with heavily contrasting shadows and highlights. The four-tone shading will give it a vinyl feel.*

2 *The level of contrast between the base colour and shadow colour helps intensify the shiny quality of the coat.*

3 *Apply additional darker shadows to the numerous creases in the coat.*

4 *Place yellow highlights on the peaks of folds where the light shines most intensely. The highlight colour is the key to giving clothing the appearance of vinyl or plastic.*

5 *Heighten this effect further with conservative use of the Dodge tool.*

METALWORK

Metals and other reflective surfaces can be complicated to reproduce due to their complex nature. The best way to understand how metals reflect is to observe how they look in real life. The shiny metallic surface reflects back all light and objects in the room like a mirror. In cel art, this is illustrated with four-tone shading, intense highlights, and shadows.

▶ In this example, each of the facets in the character's leg armour has its own highlight and shadow.

▶▶ Note that you can see the character's skin peeking through the droplet of moisture in this image.

MOISTURE

The key to capturing the properties of moisture is to make it look transparent, not blue. In this example, below, the water droplets have a white outline, small circular highlights, and a drop shadow the same colour as the character's shadow.

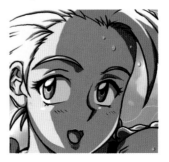

AIRBRUSH EFFECTS ON CEL-STYLE ILLUSTRATIONS

On both traditional and digital animation cel work, airbrushes are sometimes utilized for special effects. Most of the time airbrush techniques are very subtle. The tool's effects are useful for everything from softening highlights to adding finishing touches, such as blush on a character's cheeks.

INTRODUCTION TO AIRBRUSHING

Airbrushing is a really useful technique and can produce some beautiful, often subtle effects. The technique first involves colouring the character, using standard cel art techniques, and then adding effects to certain areas of the image with a blast of paint from the airbrush. This technique is most often used to soften sharp highlights, add details to the character's eyes, or add a hint of blush on the cheeks, but is also sometimes more extensively used to soften all colour divisions in the picture.

EFFECTS

The airbrush can be used to create effects difficult to achieve with sharp colour divisions. This can include small character details like the eyes or blush; reflective and transparent objects like see-through clothing, glasses, metallic items, jewellery, weapons, glass bottles, plastic containers, etc., or even objects that require a subtle gradation in colour like multicoloured clothing, or hair.

SOFTENING

The cel art/airbrush hybrid style is unique to digital art. The character is first coloured in standard cel-style fashion. After the cel-style colouring is completed, the artist then strategically blends the edges between the colour divisions with the Airbrush tool. This technique builds upon the cel art, giving the shadows and highlights a softer, realistic look.

▲ A soft, pink blush has been airbrushed gently on the character's cheeks to emphasize her embarrassment. A blush with hard colour divisions wouldn't achieve the same subtle results.

AIRBRUSH STYLE

The softening technique can also be used as a springboard for completely airbrushed pictures – working up from the cel art as your basic shadow and highlights placement, and then shading out all hard edges.

◄ This image was cel-style coloured. Effects details such as the character's eyes and the sparkles on the red dress were shaded out using the Dodge and Burn tools. The white highlights on the wine glasses were airbrushed. While the picture could easily be considered done at this point, the airbrush effects could still be taken a step further for a softer feel.

◄◄ The Airbrush tool was used to soften the character's skin, hair, and eyes, as well as add a reflective quality to the wine glass.

▼ The entire image was worked over with the Airbrush, selectively shading out portions of skin, hair, clothing, etc., for a softer look. The technique involves selecting both the base tone and the shadow tone as your foreground/background colours, and switching between them as you airbrush out sections. In some places, you may wish to completely airbrush away the hard edge, leaving only a smooth gradation between colours. In other places, you may prefer to leave a visible hard edge.

◄ The odd couple featured in this illustration both sport glasses that are shaded out using the Airbrush tool to fully capture their transparent and reflective nature. Also of note are the Satyr's golden horns. Their metallic quality was captured by using the Dodge, Burn, and Airbrush tools.

CEL ART STYLES

Once you've mastered the fundamentals of cel art, you can experiment with more advanced cel art colouring techniques to achieve a unique style. Even small stylistic decisions, such as increasing or reducing the contrast and amount of shadow and highlight tones, can help to more effectively portray the mood of your illustrations.

Although cel-style colouring is a relatively simplified colouring process, there are a number of techniques you can employ to achieve dramatically different results. So far, the focus of cel-style colouring has been the pronounced colour divisions, a varying range of colour tones from one to four, and simplified shadow and highlight shapes. The following examples demonstrate other cel-art colouring styles and techniques.

HIGH-CONTRAST DRAMATIC LIGHTING

This picture depicts an extreme usage of complementary colours and tonal contrasts between the character art, within the highlight and shadow divisions on the character art, and background art. Analogous reds and oranges make up the background and framing while an analogous, but complementary, set of greens and blues make up the base tones of the character art. Both sets of colours create a sense of colour harmony in their specific areas while serving to contrast the opposing elements of the picture. Within the character art, shadow tones are not only much darker than the base tones but are also complementary colours (light green skin set off by dark red shadow tones). Because of the use of extreme tonal and colour contrast, a boldly finished-off image is achieved with only two- and sometimes one-tone cel shading.

▲ Note how the colours are stippled to blend the yellow and orange together here.

▶ The highlight on the shoe suggests a vinyl quality.

▶▶ The simplified two-tone cel art colouring on this picture emphasizes the cuteness of this playful character.

SIMPLIFIED POP ART

This picture aims for a playful and fun look. To achieve this, some of the details, and both the line art and colouring, have been heavily simplified. The colouring consists of only a base tone and shadow tone in most cases, with only a highlight on the hair, shoes, and jewellery. On the character's skirt train, the Brush tool was used for the stippling effect that gives the colours a gradual transition from orange to yellow to green. To further emphasize the gradation of colours, subtle gradients were applied on the layer above the dress layer and set to multiply. Finally, the line art was coloured to help soften the picture and place the focus on the colours.

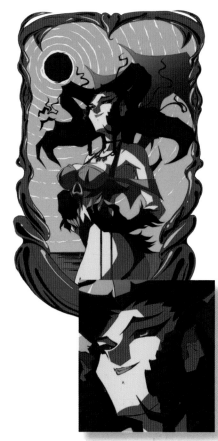

▲ High-contrast dramatic lighting.

◄ Thin slivers of dark tone between colours emphasize the colour divisions in this image.

▼ The dark tones are strategically placed at key points on the character, such as the crest of his cheekbone and nose, as well as the midpoint of his metallic armband.

COLOUR DIVISIONS

The distinctive feature in this image that sets it apart from standard cel-style colouring are the slivers of dark between the shadow and base tones. This sliver of colour, typically a tone darker than both the base and shadow tones, serves numerous purposes. It adds an additional level of detail in the colouring; it helps divide subtle shadows; it indicates a change in elevation, such as a groove or peak in body structures like muscle and bone, and folds or creases in clothing; and it intensifies metallic highlights.

Also of note are the lightly coloured bumps on the red dragon's scaly hide, which were depicted through the use of stippling with the Brush tool.

CEL-STYLE PAINTING

This picture showcases a completely different way of approaching cel-style colouring. Rather than limiting your colour palette to a maximum of four tones per section, a myriad of colours are applied. This produces a more blended, painted look, while retaining the colour divisions that set cel-style colouring apart from other colouring styles.

▲ This illustration doesn't stop at four well-placed shadow and highlight tones. Instead, it combines the sharp colour divisions of cel art with the full colour range of a painted piece.

◄ The dragon's scales are stippled with pink highlights.

8

AIRBRUSH-STYLE COLOURING

Airbrushing techniques are common in manga-style illustration. To many, Photoshop's Airbrush is the core tool in digital artwork, thanks to its versatility in photo-editing and image-production. The Airbrush is capable of producing broad ranging results, from a splash of colour to near photo-realistic colouring.

The Airbrush can be the primary tool in digital colouring, or just a touch-up tool. It achieves a soft look because there is no distinction between colours or visible brush strokes. Images that are created solely with the Airbrush tend to have a semi-realistic, smoothly shaded look. Digital airbrushing allows the artist to blend colour shades to create dramatic lighting effects.

Traditional airbrushes have controls that allow the artist to adjust the flow of paint through the nozzle. Pushing the specially designed trigger back increases the amount of paint sprayed out of the nozzle (opacity) and pressing down on the trigger increases the flow of air out of the nozzle (size).

The digital Airbrush uses your tablet, stylus, and software to simulate the look and feel of a traditional airbrush. You hold your stylus the way you would a pen or pencil. Its controls include pressure, opacity, and control. When you choose this option, the Brush tool sprays paint as long as pressure is applied to the stylus (whereas the standard Brush tool only applies colour when the stylus is in motion).

DIGITAL AIRBRUSH PREPARATION

The Airbrush is a wonderful tool that allows for smooth gradations of colour and subtle shading. As with the other brushes in Photoshop and Painter, it's important to have the tool set up properly before proceeding to actual usage. Having a properly set up Airbrush will allow you to achieve the best possible results.

SETTING UP THE BRUSH TOOL FOR AIRBRUSHING

The Airbrush tool is quite versatile and capable of producing varying effects depending on how large the brush size is set and how much pressure you exert on the stylus. Here's how to set it up. In Photoshop, with the brush icon selected on the Tool palette, open the Brush palette.

Brush tip shape options

● Change the brush size diameter to 200 pixels. While there's no specific size that's perfect for every situation, 200 pixels is a good starting point that you can adjust as necessary, depending on how large your image is and what type of effect you're trying to achieve with the brush. Larger brush sizes are better for filling areas with colour and blending. Smaller brush sizes are better for details, thicker application of colour, and more sharply defined colours. While you are airbrush-colouring your images, you'll need to be able to spontaneously increase and decrease the size of the brush. To do so, get into the habit of using the shortcut keys.

● Set the Angle to 0° and Roundness to 100%.

● You won't want your airbrush strokes to have a hard edge to them, so make sure that the Hardness is set at 0%.

● Set the Spacing to 25%. Spacing determines the distance between brush impressions. As the spacing is increased, your brush strokes will go from a continuous flow of smooth colour to a circular dab of colour. While this is useful in some circumstances, it's not desirable when airbrushing. A lower spacing percentage also works, but requires more computer processing power.

◄ Adjusting the Brush Tip Shape options on Photoshop's Brush palette.

▲ Large Airbrush spray.

▲ Airbrush stroke.

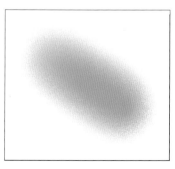

▲ Airbrush stroke with noise.

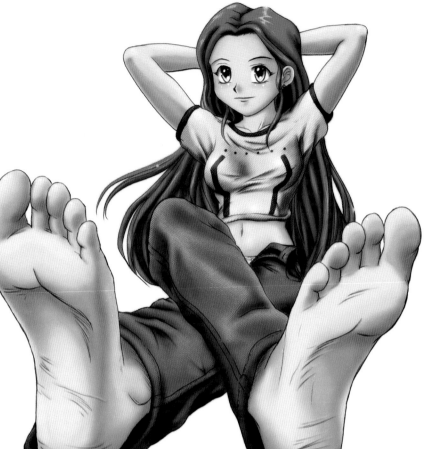

◀ Airbrushing is a combination of broad body strokes and small, detailed strokes. In this image, larger strokes build up the shadows and blend areas of colour. The smaller, more defined strokes are used in foreground details, such as the feet, where they're used to emphasize folds.

▲ Small Airbrush spray.

▲ Other Dynamics options on the Brush palette.

BLENDING COLOURS

A primary technique used in airbrush-style colouring is colour blending. In addition to the Airbrush, colour blending makes use of the Eyedropper tool. This section will show you how to utilize these tools to fully blend your colours, and produce subtle lighting effects.

THE EYEDROPPER

In most situations, the Eyedropper tool is used to select a specific area of colour, but you can also use the tool to take an area average colour rather than a point sample. This can come in handy for airbrush-style colouring, allowing you to blend adjacent tones quickly and easily.

You'll be using this tool often while airbrushing your picture. Fortunately, the designers of Photoshop made a handy shortcut key available so you can quickly eyedrop colours and then get back to working on your image. Holding down the Alt key will temporarily change your brush into the Eyedropper tool. When you release the Alt key, the Eyedropper tool will revert to whichever tool you were using last.

The Eyedropper menu gives you three different methods of colour selection to choose from. For regular usage, the tool works best when set to Point Sample, but for airbrushing, choosing 5 x 5 Average will assist your colour blending.

With the Eyedropper set to 5 x 5 Average, clicking on the centre line between the colours produces an area's average colour, which in this case is a muddy green. Had the tool been set to Point Sample, the selected colour would have either been yellow or blue.

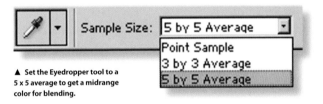

▲ Set the Eyedropper tool to a 5 x 5 average to get a midrange color for blending.

▲ First, a layer of flat colour is laid down using a large Airbrush spray.

▶ Next, an initial layer of purple shadow tones is airbrushed over the top.

▲ The average colour between the character base and shadow tone is captured using the Eyedropper tool.

▲ Finally, the colours are blended out using gentle pressure with a medium-sized Airbrush tool.

BLENDING TECHNIQUES

Start the blending process by choosing a medium-to-large brush and then use the Eyedropper tool to select the first shadow tone. With gentle strokes, go along the edges between the shadow and base tone. Be wary of the amount of pressure you use: too little and the blending will take forever to accomplish, too much and you'll cover your base tones with the shadows rather than blending them.

As you blend out the colours in your image, your image will begin to look much smoother and more lifelike. When you blend your tones together, use the Eyedropper to select the mixed tone between the two divided areas of colour. Continue blending out the edges between the tones until there is a smooth gradation from one tone to the next. Like before, don't go overboard with the blending. There should still be plenty of base tone remaining and plenty of space for highlights. With the shadow tones blended,

the character's skin takes on a much softer, fleshier appearance. The drawing obviously says 'manga', but the airbrushing casts a bit of interesting realism that demonstrates the usefulness of the Airbrush tool in manga artwork.

▼ Airbrushing isn't always about capturing realism or three-dimensionality. Some artists, such as well-known illustrator and character-designer Aoi Nanase, tend to be more ethereal with their technique. This style, where the line art carries the picture, is well-suited to a soft airbrushing technique. (Image from *Angel Flavour*, copyright 2003, Aoi Nanase.)

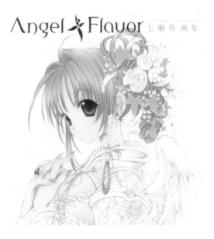

▼ Creating three-dimensionality in a picture requires the right amount of blending in the right places.

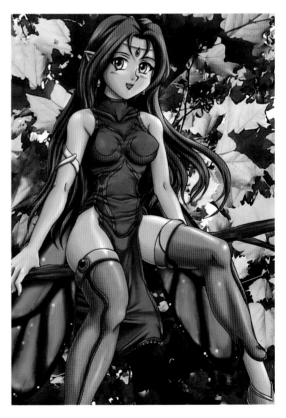

STEP-BY-STEP AIRBRUSH

Airbrush-style colouring allows you to achieve softly blended gradations of colour. For an authentic look, the key is to minimize brush strokes, and avoid distinct colour divisions. This section will walk you through the airbrush process from start to finish.

1 *Open up your image in Photoshop, and begin filling in colours just as you would for a cel-style picture, with the line art as your topmost layer, and each area of your image (skin, hair, clothes, etc.) divided into separate layers. Don't forget to check the Preserve Transparency box once done, to prevent airbrushing outside the coloured areas. With only one-tone shading, the character looks a bit flat, but this is only the first step in the airbrushing process. As you add shadows and highlights, the picture will become more three-dimensional.*

2 *Make a quick colour sketch to get a rough idea of the general colour scheme, and where the shadows and highlights will be placed. Select muted reds and purples to establish the setting and mood of the coffee shop. The light source comes from the row of lights on the ceiling shining down upon the character.*

3 *Once you have determined a light source and colours, you can begin to add shadows and highlights. No matter what area you choose to start colouring first, keep your shading value and placement consistent. If the value of the shadows on the character's skin goes from a light pink to a dark brown, you should continue to keep this degree of shading consistent in other areas of your picture as well. In this image, the character's skin is extremely pale, so even a slightly darker shadow provides a satisfactory amount of contrast.*

4 *Still far from complete, add more layers of shadows to the character's skin, keeping in mind the location of the light source. Add purple shadows to the side of the character's face to simulate the light radiated off of her purple shirt. Add a base red shadow tone to the hair, only casually blocked in at this point. Making full use of the Airbrush's gradual shading abilities, fade the colour subtly from base tone to shadow down the length of the hair. You may need to make several passes of shadow with a medium-sized brush to achieve the colour fade.*

5 *Add more highlights and shadows to the skin and hair, blending carefully to attenuate any sharp colour divisions. At this point, the hair takes on an almost metallic appearance, with many layers of sharply contrasting shadows and highlights. Add detail to the character's lips and eyes.*

6 *Colour the character's clothing and jewellery in similar fashion, starting with soft, fuzzy shadows, building up colours, and blending as necessary to achieve the desired level of gradation. Give the jewellery around the character's neck an appropriate number of highlights to accentuate its metallic properties.*

7 *Colour the mug and coffee container with special care to capture the properties of liquid, steam, transparent glass, and water droplets. Finally, to complete the picture, add detail to and refine the background until you are satisfied with the result.*

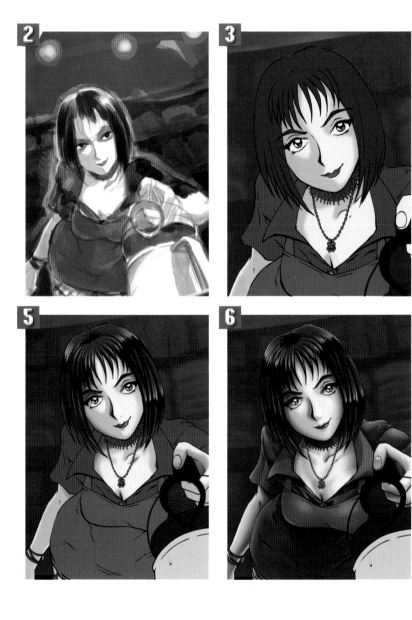

AIRBRUSH IN DETAIL

Focusing on the airbrush-style colouring of specific elements such as hair, eyes, metallic objects, and liquid close-up in step-by-step detail, this section shows how to use various brush, colour layering, and blending techniques to create convincingly different materials and textures.

HAIR

1 *Starting with the base tone, lightly apply a dark red shadow tone to the entire length of the hair, darkest at the bottom. From there, the hair is worked into with the smaller-sized brush, using the base tone to help separate the hair strands, and add dimensionality to the hair.*

2 *As you build up the shadows and highlights, the hair develops a metallic shine. This shine is achieved by placing an extremely dark shadow next to a highlight. Add a hint of purple to the bottom tips of the character's hair, reflecting the purple shirt. Use the Smear tool to pull shadows and highlights into sharp points.*

3 *Finally, to give the hair a more streaky appearance, add numerous white highlights throughout, making thin strokes with a small brush size, particularly in locations most likely to be affected by the light source. Along the top of the hair, place highlights to accentuate the shape.*

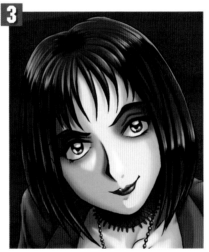

EYES

Executing the eyes is a question of style. When you do the pupils, use a small brush for better detail. Consider adding a shadow tone underneath the upper eyelid; doing so makes the eyes look more like they're set into the head, creating the impression of three-dimensionality. A special touch is the eyeshadow around the character's eyes. The heavy shadows are applied generously around the eyes on a layer set to Multiply above the skin layer.

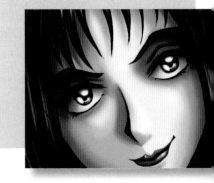

LIQUID

To give the coffee cup a realistic ceramic quality, use wide, sweeping brush strokes of shadows and highlights. Before creating the water droplets, first observe real water droplets. Reproduce them by building up colours with the Airbrush, starting with a brown base colour, and adding a darker shadow along the bottom edge, along with white highlights to represent the light passing through the droplets.

JEWELLERY

The character is wearing several pieces of jewellery in this image, including a couple of bracelets, a ring, and two necklaces. Metallic objects, to a greater or lesser degree, have a reflective surface. Depending on how dull or polished the surface, the metal may reflect only the most significant light sources (dull brass, for example), or it may reflect an area like a mirror (highly polished silver). In the case of metal objects with a dull finish, some of the reflective properties are lost, but the metal will still show concentrations of light and dark. To reduce the metal-colouring process down to its simplest properties, metal looks shiny. That's the quick and simple way of identifying metal objects in a picture. They tend to have lots of prominent highlights, as well as unusual, dark streaks all over them. Use the Dodge tool to make some of the highlights appear more radiant. These contrasting tones are reflections of dark and light in the surrounding area.

COFFEE POT

1 *To fully capture the realistic qualities of the coffee pot, gather reference materials, such as digital photos of coffee being poured, and study them.*

2 *Colour the coffee pot in multiple steps, starting with the liquid. Airbrush the edge of the coffee pot, where the liquid is more translucent, with an amber colour and add a yellow highlight to the edge.*

3 *To depict the steam, select the parameter of the pot and softly airbrush with white on a layer above the line art. Make the condensation streaks by erasing portions of the white steam layer with the Eraser tool set to Airbrush.*

9

PAINTING-STYLE COLOURING

Manga as fine art? The combination of realistic, detail-driven painted artwork can lead to breathtaking results. While colouring styles such as cel art owe their origins to commercial production art (animation), traditional painting styles can be traced to the greats. While both are effective colouring styles, there's a certain majestic appeal to painted-style colouring.

Achieving the look of traditional oil or acrylic paintings is no small feat, however. Painting is one of the more involved methods of colouring, requiring numerous layers of brush strokes from the base paint layer to the layered final result, a vigorous amount of blending, a higher degree of planning, and reference material to help capture realistic details. Painting de-emphasizes the line art, lending more weight to colour theory, contrast, and brush strokes.

Thankfully, Painter comes fully equipped with an array of adjustable tools and brushes suitable for painting styles, and the digital medium allows for experimentation.

However, simply having the tools at your disposal is not enough to create a painted picture; it's how you utilize them. This chapter details the ins and outs of digital painting, including setting up your brushes, using different brushes to yield different results, brush strokes, blending, and other painting techniques, blocking in colours, working from back to front, underpainting, utilizing paper textures, and various effects.

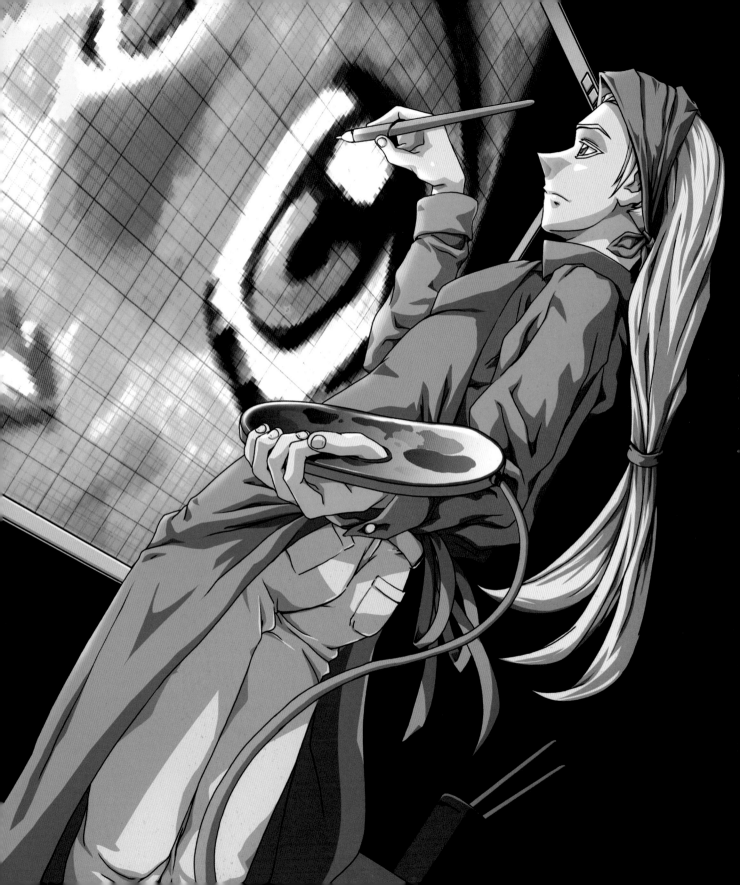

DIGITAL PAINTING PREPARATION

It's possible to digitally paint using Photoshop, but the painting demonstration in this chapter makes use of Corel Painter and its wide variety of tools and brushes.

USING PAINTER

Painter comes equipped with so many different brushes that it's possible to paint a picture any number of ways. This section will introduce you to a selection of brushes that can be used for painting, each yielding a different result. Be sure to also experiment with other tools to achieve other styles and find brushes that you feel comfortable using.

TOOLS

You will switch between many different tools while painting, so it's helpful to make a custom palette that holds all of your painting brush tools in one place

Oils: Oily Bristle (Painter IX+ only)

Useful for blocking in colours with distinctive rectangular brush strokes that give the feel of a traditional painting. The properties of the Detail Oils Brush allow for some interesting effects, but make it somewhat difficult to work with. It starts fully loaded with paint, and slowly runs out as you run your brush along the digital canvas.

▼ **Make up your own customized palette.**

Oils: Detail Oils Brush

Also useful for blocking in colours, this brush is easier to control than the Oily Bristle, with a smoother and faster application of colour that lacks the emphasized brush strokes. This is the primary brush tool used for everything from large to small details. It's not good for blending, however.

Oils: Flat Oils 1

Its brush properties fall between that of the Detail Oils Brush and the Oily Bristle. It has a brush stroke with a lot of personality and variety that makes it useful for rougher and/or unpredictable elements that require texture such as clothing, vegetation, rocks, water, etc.

Blenders: Just Add Water

A tool used for blending colours placed by other brushes. It pulls and diffuses colours to help blend and smooth brush strokes.

Blenders: Water Rake

Also used for blending colours, the Water Rake has a grainy consistency to its strokes.

Palette Knives: Smeary Palette Knife

Used for pulling and streaking colour across an area of the image. Its tilt-sensitive nature makes it difficult to control and somewhat unpredictable, but it's extremely useful for creating interesting textures.

▲ **Olly Bristle.**

▲ **Detail Oils brush.**

▲ **Flat Oils 1.**

BLENDING TECHNIQUES

Artists' Oils: Oily Bristle

As the colour runs low on the Oily Bristle brush, strokes blend with underlying colours and eventually the dry bristle smears and blends. To get just the right effect throughout your picture, modify the Artists' Oils setting on the Brush palette as necessary.

Oils: Detail/Flat, etc. and Blenders: Just Add Water

Oils don't so much blend as they do cover. Therefore, use Oils to block in colours and Blenders to smooth colours out where necessary.

▲ Base tones laid down with the Oils brush.

▲ Just Add Water.

▲ Tones are pulled into one another along the edges using Just Add Water and light, zigzagged, perpendicular strokes.

▲ Water Rake.

▲ Basic object shape is blocked in.

▲ After a criss-crossed set of brush strokes, the dividing line between colours is almost completely blended, leaving a smooth gradation between the colours.

▲ Smeary Palette Knife.

▲ The brush settings are changed to cause the brush's paint to quickly run out. Shadow and highlights are stroked and chopped in over the previous layer of paint.

A NOTE ABOUT LAYERS

Another feature of digital painting that sets it apart from other colouring styles is the ability to work on a single layer. While layers are crucial components of other colouring styles, they aren't entirely necessary in digital painting (although they can still be used to separate portions of the image). Some painting techniques are only possible from working on a single layer.

STEP-BY-STEP PAINTING

Digital painting differs substantially from other styles of colouring, such as cel style and airbrushing. One of the most striking differences is that digital painting doesn't require line work to be fully rendered or inked. You can simply work from a rough sketch, putting details into the image through colours and brush strokes.

1 *Start by opening up your sketch in Corel Painter. Regardless of the level of completion of the drawing, be sure to have a firm idea of what you wish to accomplish. In this picture, the desired final result is a girl, dressed in a frog costume, standing in the middle of a body of water, with frogs perched on rocks in the background observing her.*

2 *Rather than separating the image into various sections of flat colour, as for other colouring styles, block in the entire picture with colours on a single layer, using the Oily Bristle brush. This will allow for an easier build-up of colours and blending. Opting for a sedate colour palette, limit the colours to cool, monochromatic blues. Don't worry about straying over the lines at this point since there are no finished areas yet.*

3 *Still using the Oily Bristle brush, build up the colours on the character's face by first placing down a base flesh tone and then adding dabs of shadow and highlight colours over the top of it. The brush strokes may only need to be rough, but as long as the placement is correct, that is the most important thing. The light source should come from above, centred on her like a spotlight, so place the shadows mostly around the edges of her face, and areas like her neck, nose, brow, and lower lip, which may be covered and in shadow.*

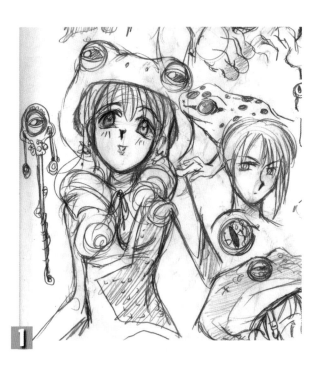

4 Periodically, flip the image for a fresh look at the character's form and shadow/highlight placement. If necessary, refine details such as the character's eyes, lips, and frog hat. Block in the shape of the hair in a separate layer, allowing you to do work on the hair without interfering with the portions of the image you've already painted.

5 Once you've established the basic form of the hair, merge the hair layer with the painting layer for further integration. Block in darker shadows to give the hair more depth. Then, use the Just Add Water brush to gently blend the brush strokes in the face and hair. Work reds into her outfit to give her the look of a poisonous frog. Finally, do the indentations on the frog hat on a layer above the painted layer. Dot darker shadow colours onto the hat with the Detail Oils brush and then build up with a lighter highlight colour.

6 For more unified colour scheme, change the red of the outfit to green and blue using Hue/Saturation in Photoshop. Once back in Painter, build up the shadows and highlights on the outfit, but do not blend just yet. Add detail to the staff. For a metallic appearance, choose shadow and highlight colours that sharply contrast each other. Finally, make adjustments to her right hip and leg so that they look more anatomically correct.

Blend out the outfit's shadows and highlights, followed by additional passes to add details, areas of extreme darkness and brightness, and to increase the amount of gradation between highlight, base, and shadow. Pay careful attention to keeping the tonal values of the shadows and highlights similar between the blue and green. Add small indentations to give the outfit a more frog-like texture, following the same steps as those on the frog hat. Draw a thin, light blue edge between the colour divisions to create a seam. Readjust the dangling metal rings on the staff to correct their placement relative to the character's body.

7 Finally, with the character art complete, paint the background details, working from back to front and using brushes such as the Flat Oils 1, and the Water Rake for texture.

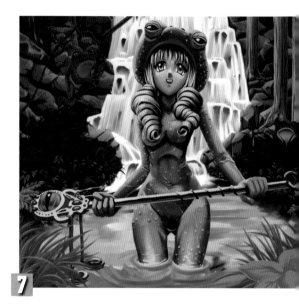

7

4

5

6

PAINTING IN DETAIL

While different areas of the picture utilize various techniques, the same principles are applied throughout the image: block in the base colour, then the shadows, blend, then block in the highlights, blend, add additional shadows and highlights, and finally blend and detail until you're satisfied with the results.

HAIR

There are many ways of drawing and colouring hair. Some artists choose to indicate strands; some represent the hair as one mass, and some leave the colour as one consistent tone, letting the line work suggest detail and depth. How you choose to tackle hair is as much an indication of style as anything else in your images. There's no single concrete technique for colouring hair; it varies from picture to picture based on what effect or mood you're trying to achieve.

1 *Lay down the hair's base tone using a large Detail Oils Brush on a new layer above the painted layer. Working on a new layer allows you to block colours without worrying about messing up previously painted areas. Place an initial set of shadows using a smaller-sized brush.*

2 *Work in darker blue shadows to give the hair more form and contrast. Place highlights where the light hits the hair's curves and bends using vertical strokes with a small Detail Oils Brush. Try to give some variety to your brush strokes (some lines are longer than others), always making sure they follow the flow of the hair.*

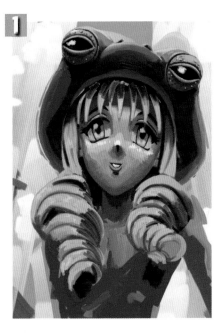

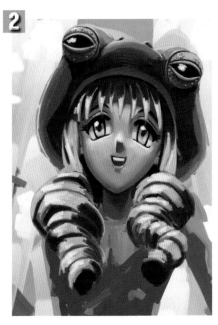

3 *Blend out the colours using the Just Add Water brush. Add additional levels of shadow and highlights with the Detail Oils Brush. Lightly blend these colours again with the Just Add Water brush, giving the hair a nice, smooth gradation of colours while retaining its texture and form.*

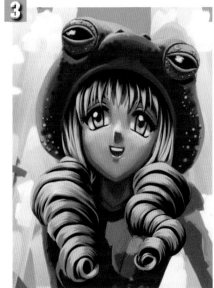

THE BACKGROUND

1 *Working from back to front, block in the basic form of the background with colours, starting with the small, rocky area on the upper left-hand side of the picture. As you are working, you'll be putting elements in front of other elements. Naturally, you'll want your rocks to be complete before you start painting in overlapping grass blades. To cover a lot of area quickly, you require a large-sized Detail Oils Brush. For added texture, use the Flat Oils 1 brush. Complete the rock's shadows and highlights with the Oily Bristle; the visible brush strokes add more personality and texture.*

2 *Observing reference photos taken of waterfalls, block in the water with whites and blues as well as darker greys to represent rocks. Following the flow of water, create streaks of colour using the Smeary Palette Knife brush. The palette knife applies the selected colour (in this case white) when a moderate amount of pressure is used. Otherwise, it simply pulls previously placed colours. Both techniques build up the waterfall.*

3 *Using the Detail Oils brush, build up the foliage, starting with the dark shadows. Add lighter colours on top to create an illusion of depth. For more variety, paint other types of vegetation using the same technique (dark to light). Additional grass and leaves can be painted into the foreground using quick strokes of colour.*

10

WATERCOLOUR-STYLE COLOURING

The translucency of watercolour sets it apart from other styles of painting. From building up colours and glazing, to colour washes and 'wet-on-wet' versus 'wet-on-dry', each technique creates a unique result, all of them quite different from digital acrylics and oil paints.

Painter's watercolour brushes simulate traditional watercolour tools. However, anyone who's worked with traditional watercolours will be quick to spot the differences between the two media. For instance, digital watercolours do not bleed and diffuse like traditional watercolours, nor do they dry over time. This limits the possibility of 'happy accidents' – a common feature of traditional watercolours – but also allows for more control. Painter's Watercolor tool may not perfectly imitate traditional watercolours, but it's still an excellent tool.

Painter's watercolours are more similar to the other digital colouring tools than traditional watercolours. The colour comes out in circular dabs of various widths and opacity. The big difference between the watercolour tools and the other tools is the gummy abrasiveness, and their opacity when colours are layered. The Watercolor brush pulls underlying colour with each new stroke, blending the colours at the same time.

This chapter covers numerous digital watercolour-related topics, including which tools to use to most closely capture the traditional watercolour look, and how to set them up; brush strokes and blending techniques used to create a variety of watercolour styles, how to accurately portray different types of fabrics and textures; and, of course, the step-by-step process from initial preparation to finishing touches.

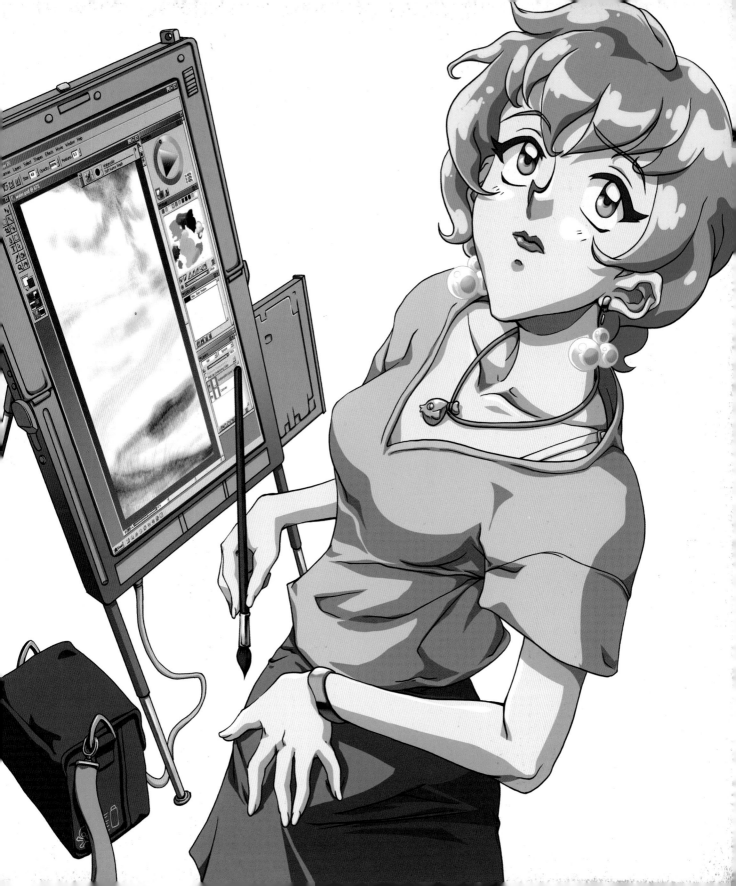

WATERCOLOUR PREPARATION

The Watercolor tools in Painter IX work differently than other brushes. They are confined to their own wet layer until dried, and by default are heavily affected by paper textures. This section introduces a number of basic watercolouring concepts, as well as brushes that simulate the look of watercolours.

THE WATERCOLOR LAYER

The stroke data of the Watercolor brush is contained on a wet layer, separate from normal layers. Non-Watercolor brush strokes, such as pencil lines, will remain unaffected even when overlying Watercolor brush strokes are erased. Unlike previous versions of Painter, where there was only one invisible wet layer, creating new layers will make additional wet layers. This allows you to separate portions of the image as required without needing to dry the wet layers first.

◄ The iridescent scales on this snake's head were done quickly with remarkable results. The look was accomplished by brushing over the painted image at low opacity with the New Simple Water brush while the paper type was set to 'Veination'.

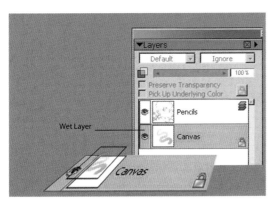

▲ The wet layer is an invisible layer separate from standard layers, which contains any Watercolor brush strokes you make within the program.

Be careful when you save your file. Wet layer information is only retained on Painter Riff files. Only save as a PSD when you are done with the picture, as converting a file into PSD will dry all wet layers.

To merge watercolours with the normal layers, choose Layers>Dry Digital Watercolor. Keep in mind that once a section is dried, you won't be able to work into it anymore with the Watercolor tools.

PAPERS

Just like with real watercolours, the painting is affected by the type of paper used. The Watercolor tool is affected more by the paper texture than most other tools, and this can be used to your advantage if you plan ahead. The watercolours will mimic attributes of the paper, flowing off elevated areas, and sinking into grooves and indentations.

Using watercolours in conjunction with the paper textures can produce some excellent special effects. For general usage, I would suggest using a paper that has very little texture, or reducing the brush grain to zero.

◄ Two colours are used on the face, a base and highlight. All application and blending are done using the New Simple Water brush.

BRUSHES

Painter includes a number of different types of brushes for watercolouring: the realistic but resource-intensive Watercolor brushes, the Tinting brushes, and the Digital Watercolor brushes. This section focuses on two of the Digital Watercolor brushes.

Digital Watercolor: New Simple Water brush

This is your all-purpose Watercolor painting brush. Throughout the painting process, you'll need to resize this brush often. When the brush is sized-up large, it's good for laying down washes, filling large areas with colour, or even blending. When the brush is sized down, it excels at colouring details. For more build-up, drop the opacity. Glaze layers of watercolour over each other for subtle blending effects.

Digital Watercolor: Pure Water brush

This brush is used for blending colours and paper effects.

For blending: with the opacity set low, around 20%, low- to medium-pressure brush strokes gently blend colours. Heavier-pressure brush strokes pick up underlying colours and push them around your image as if you were finger-painting.

For paper effects: setting the opacity down to about 10% creates a brush that is excellent for expressing paper textures in your image. A gentle stroke will subtly blend the underlying colours while expressing the paper texture. A heavier stroke will heavily blend the underlying colours, and make the texture more apparent.

▲ The colours are blended together into a smooth gradient by using the Pure Water Brush on a textured paper.

STEP-BY-STEP WATERCOLOURS

Once your papers and brushes are prepared, you are ready to start watercolouring! The wet-on-wet technique used here works, quite bizarrely, in the opposite manner to traditional watercolours. This section shows you how.

As with digital painting, your line art need not be inked or transparent, but it should be fairly clean and dark. The snowflake girl featured in this section is painted wet throughout the entire step-by-step process, and is only dried at the end once the picture is complete. The wet-on-wet technique actually works in the opposite manner to real traditional watercolours. Instead of starting light and working in shadows, wet-on-wet allows you to start dark, and build up highlights from there, even to the point of painting in whites!

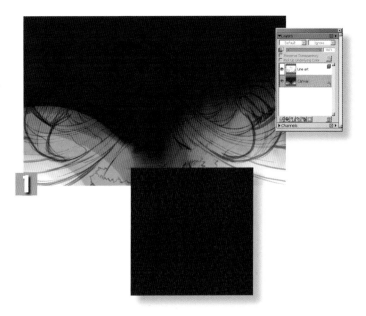

1 *The pencil line work is opened in Painter IX. Working on a single wet layer, start by blocking in the background with a dark blue to represent the night sky using a large-sized New Simple Water brush. Apply medium pressure to add the Basic Paper (and later, Pebble Board) paper texture to the colour. Along the bottom portion of the picture, apply bands of yellow, orange, and red and blend into the blue.*

2 *Paint a light purple around the edge of the character to give her a subtle glow. Work pinkish white orbs into the background. Finally, from the top, apply a vivid blue and pull into the darker blue, smearing directly over the orbs as necessary.*

3 Blend out the vivid blues and the white orbs using the Pure Water brush. For a little extra sparkly magic, gently spray the Digital Watercolor brush Salt into the blue background. Block in the character's coat with red and lightly blend, allowing the dark blue of the background to show through as the shadow colour.

4 Paint light pink highlights into the red coat. Block in the fuzzy trim on the coat and ears with a darker purple colour in small dabs. Block in the scarf and blend with greens and blues, still allowing the yellow of the background to peek through in the front as a highlight. Mixing the flesh tone with the blue background, block in the character's face.

5 Continuing to detail the face, apply the highlights and shadows and then blend out to build up the form. Add further definition to the facial features such as her eyes and mouth using the New Simple Water brush like a pencil. Add subtle purples and blues to the whites of her eyes and teeth.

6 Apply a base purple colour to the hair and blend with the blue background, followed by lighter and darker purples to add depth – judiciously so as not to completely cover the underlying yellow. Colour in the gloves, hats, and ribbon in a similar fashion, using the background as the initial shadow colour and building highlights up from there.

7 Build up the coat's fuzz from dark to light with small, short strokes in all directions. Similarly, build up the scarf's tassels, starting with the darker colours and layering with lighter colours. If the colours of the face seemed too muted, make a couple more passes on the face with lighter colours.

8 Next, dry the picture and save as a PSD and import into Photoshop. Apply some pink blush to her cheeks and nose with the Airbrush tool. Apply a snowflake texture as a layer set to screen above the painted layer. Finally, change the eye colour to green using Hue/Saturation and brightened with the Dodge tool.

WATERCOLOUR IN DETAIL

The process of colouring clothing is a little different to the process for colouring skin. Hair and skin can appear to have a vibrant shine or gloss on the surface under certain lighting conditions. This is especially true in manga-style artwork, where characters have very distinct highlights on their hair and skin, giving them a 'plastic', stylized look.

COLOURING CLOTHING

Everyday clothing is generally made out of cotton or other soft material that doesn't reflect light well. Cotton naturally has a matte appearance. Colouring for this type of material would generally require only minimal shading.

The way the fabric is coloured directly affects the appearance and texture of the fabric. Cotton fabric with a bright shine will look like vinyl, not cotton. If you were colouring a polished leather jacket, many bright highlights (especially where the jacket creases and folds) would help depict the leather's smooth texture.

Different types of fabrics will have different types of shines and textures. To realistically depict the fabric of your choice, research your subject and see how shiny or dull it is when light hits it. Silk, polyester, and rayon are all very smooth, sleek fabrics; silk has a surprisingly very dull shine, whereas the others are very shiny.

▲► **Different fabrics have different textures and reflect light accordingly. Some fabrics, such as leather or vinyl, will have a high shine, but cotton and wool are matte.**

THE WOOL COAT

The snow girl's coat is a heavy fabric, such as wool, requiring a matte finish. This involves laying down a base colour over the background colour, which plays the role of the shadow colour, followed by blending, using parallel strokes. Afterwards, perpendicular strokes are applied to pull the shadows into the base colour. A dull shine where light is cast upon the coat is achieved by adding a lighter tint of pink along the edges with semi-opaque brush strokes. Doing this builds subtle edges, giving the illusion that there are minor undulations in the fabric. The reds and yellows still show through on the lower portion of the coat, providing additional visual interest.

THE TRIM

The fuzzy trim on the coat is also built up, starting with the underlying background colours. Small dabs of colour are layered upon each other into the New Simple Water brush with minimal blending to retain stroke shape. Each layer of colour is lighter than the one before and, by starting with a dark colour, it is possible to do numerous build-ups of colour before reaching white.

THE HAT

The hat and ribbon also rely upon the background colour for their shadow tone. The hat, while not entirely requiring an eye-catching shine, is more in the light than the other portions of the outfit and calls for a more pronounced highlight. A light blue highlight is thickly applied around the edges of the hat to make it stand out from the background. The ribbon is coloured in a similar fashion.

BACKGROUNDS

Manga-style artwork tends to place emphasis on the characters rather than their surroundings. Backgrounds are often sparse, shown only when required to set the scene. In the anime industry, artists have made careers from specializing in character artwork, neglecting backgrounds completely. With such little importance placed on backgrounds, why concern ourselves with them?

Backgrounds may not be the focus of the image, but they do add to its impact. A well-executed character may look great by itself, but put it in front of an appropriate background and it'll have much more visual impact! Backgrounds build a natural bridge between character and setting. They give characters a world to exist in and interact with. They also help to fill up negative space, and convey a message.

A background doesn't necessarily have to be a detailed scene. Types of background can range anywhere from simple flat colours, to design elements like text and shapes, patterns or gradients, photos, or imaginatively painted scenes.

It's important to treat the background as part of the overall image, not as an afterthought. Even if you leave the background as the last step, work it into the initial image composition right from the conceptual stage, and make sure that the relationship between character

PAINTED BACKGROUNDS

Painted backgrounds are excellent for portraying realistic and semi-realistic scenery. They integrate well with cel-style character art, but are equally compatible with character art of any colouring style. This section covers the background painting process step-by-step using Photoshop, with instructions on how to set up your image and tools.

PAINTING BACKGROUNDS

Painting realistic, perfectly lit, three-dimensional structures with all the little nuances that they can contain requires an understanding of fine art concepts and a lot of time. Don't be surprised if your first background doesn't turn out looking like a masterpiece. Just keep working at it, and the quality will improve considerably. Although backgrounds are almost never the focal point, the quality of the background will stand as a marker to determine the quality of the picture as a whole.

▼ **Use the Organic Painting brush to capture realistic tree bark and branches.**

CUSTOM TOOLS

To paint the background, several custom brush tools were used.

Organic Painting Brush

The brush is useful for colouring organic-looking objects. It provides rich, opaque colours while still lending itself to blending fairly well.

- Brush Tip Shape:
 Choose a hard, round brush
- Diameter: 90 pixels
- Angle: 0°
- Roundness and hardness: 100%
- Spacing: 20%
- Shape Dynamics
 Size control: Pen Pressure
 Minimum Diameter: 1%
 All other options set to 0% and off
- Other Dynamics
 Opacity control: Pen Pressure
 All other options set to 0% and off

Cloud Brush

- Brush Tip Shape:
 Choose a soft, round brush
- Diameter: 9 pixels
- Angle: 0°
- Roundness: 100%
- Hardness: 25%
- Spacing: 15%
- Shape Dynamics
 Size control: Pen Pressure
 Minimum Diameter: 1%
 All other options set to 0% and off
- Other Dynamics
 Opacity control: Pen Pressure
 All other options set to 0% and off

▲ **The Cloud brush is ideal for creating the right texture for skies.**

1 Start by blocking in a rough, colour sketch of the background using the Organic Painting brush. It helps to have your completed character artwork (or at least a sketch if you plan on colouring the character second) on a layer above the background. This lets you know which portions of the background need to be painted, how the character is interacting with the background, and where shadows should be placed.

2 This background is a beach scene, broken up into three distinct portions: sky, ocean, and sand. Paintings are traditionally worked from back to front, building up from the colours in the background. Starting from the top, make up the sky using yellows, greens, and blues, followed by overlapping clouds using the Cloud Brush. If your clouds don't capture the right mood, you can always start again. If you're inspired to do something slightly different with your background while you're painting, don't be afraid to improvise!

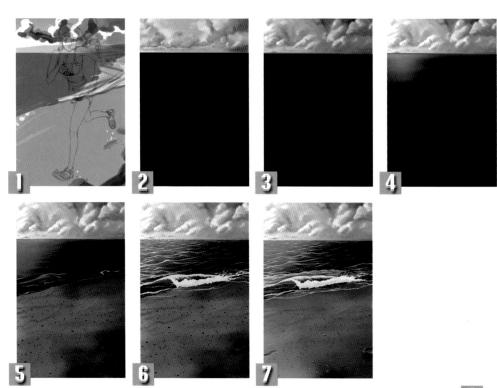

3 A second attempt at the sky leads the picture in a more desirable direction. Using darker, more dramatic colours, build up the sky again, starting with the dark grey blues of the background and building up the grey-yellow clouds.

4 After some final lighting adjustments to the sky, block in the ocean with dark blue and then softly blend using the Airbrush tool. To depict the rising sun just after dawn, give the left-hand side of the picture subtle highlights, including a hint of sunlight peeking through the clouds and a lighter blue upon the ocean.

5 Draw in the edge of the ocean with a thick, white line. Block in the ground with dark purples, inserting some heavy, black shadows where the character is interacting with the sand. Apply a stock image of speckled black dots to the sand to add texture.

6 Work into the ocean using lighter blues and whites for waves. Use the Cloud Brush to create the thick foam of the wave cresting and hitting the sand.

7 Build up the waves in the foreground further, and lighten the waves far in the background to emphasize the distance. Work into the speckled dots in the sand with some white highlights for a more three-dimensional look. Finally, paint a footprint into the sand.

8 Combine both the character and background art for a final and complete picture.

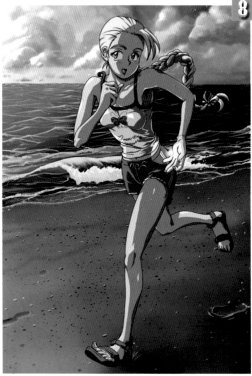

CEL COLOUR BACKGROUNDS

While cel-style colouring is primarily used for character art, it can also be applied to backgrounds. The result is a nice, clean look that gives a lot of visual impact with a minimal amount of work.

DIFFERENT APPROACHES TO BACKGROUNDS

Creating a cel-style background involves the same general technique for cel-colouring character art: using the Freeform Pen tool for layering sharply defined, flat colours to suggest shadow and form. This section outlines the pros and cons of using cel-style backgrounds, and goes over several ways of approaching this unique style of background art.

The simple background

One problem with cel art backgrounds is that their sharply defined colour divisions encourage the background to compete with the character art for attention. One way to get around this issue is to omit the lines – in effect blurring the background – and keeping the focus on the character art. Simplicity is the key here.

It's best to plan out your backgrounds when you're still in the initial planning stages. You don't necessarily need to have inked or even pencilled line art in your background, but you'll want to have a rough sketch of the background to use as a template for placing colours.

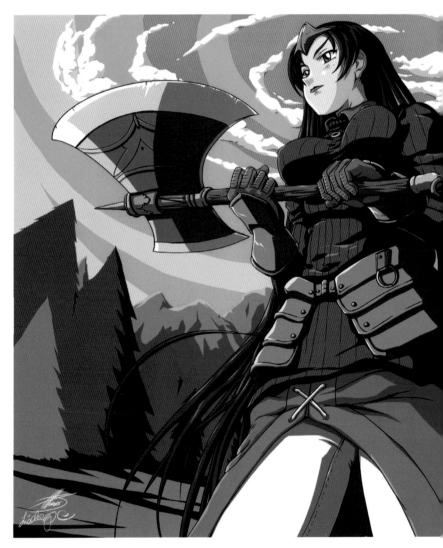

▲ The background in this image uses a limited colour palette of oranges and browns to complement the character's expression. Despite their simplicity, the shapes and colours successfully suggest a scene filled with trees, mountains, and sky.

Backgrounds using line art

Line art is important for backgrounds with details too intricate to easily portray with colour alone.

Of special note are the burning candles in the upper right and left corners of the picture, as well as on the bookshelf behind the character. The flames are rendered as pure flat colours without lines. The colours on the stones surrounding the candles are lightened to create a convincing glow effect. With the light coming from above, a shadow is placed beneath the character to indicate a drop shadow. When colouring your images, don't forget to give your character a drop shadow if the situation calls for it. However, be careful to only apply shadow where the picture would realistically require shadow. If you add too much shadow, or add shadow where it shouldn't go, the character will look like he or she is floating.

Backgrounds without line art

Sometimes the background in an image doesn't require the use of line art and is actually more effective without it. In this example, to accurately portray the lush details of nature, lines are eschewed in favor of contrasting colours. The bristly two-tone dark green pine trees easily stand out against the pink sky. The rock's edge highlights separate it from the trees, while its darker interior contrasts with the character's white dress.

This background almost exclusively utilizes the Brush tool, as opposed to the Freeform Pen tool, as indicated by the rough-textured edges between colour divisions. This is not usually a desirable trait in a cel art image, but in this case, the irregular edges help give the background a more organic look. The Brush tool was also used for small details. Speckled greens and yellows hinted at growing vegetation; using quick brush strokes of light green layered on the darker green backdrop indicates grass.

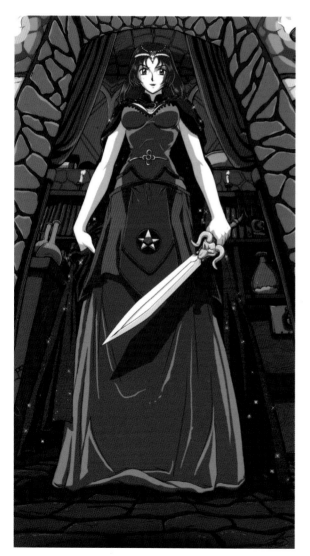

◀ The cel art background in this image presents a more involved approach. The background is fully inked and highly detailed, unifying character art and background art.

▶ This image showcases a detailed outdoors background with cel-style colouring without line art.

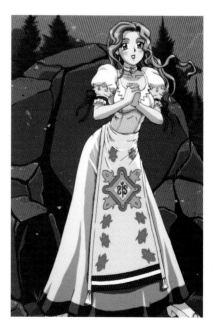

PHOTO BACKGROUNDS

Photographs can be a good substitute for a graphic or painted background, and are easy to create. If you have a decent digital camera, snap off a photo of an object or location, and use as a background layer. Often, the best kind are those that make use of filters or special effects, or involve retouching.

CHARACTER INTERACTION

Don't wait until your picture is finished to decide on your background. Take the time to plan from the beginning. For example, if you want to depict a character sitting in a chair that's part of a photographic background, you'll need to draw the character so that he or she will interact with the background. Make sure that the perspective and lighting match the character art. If the character art is simply placed over any photograph without planning, it's going to look amateurish.

RETOUCHING AND REARRANGING

Retouching can be time-consuming. Depending on the size, quality, and numerous other factors, you may need to work into your photographic background to get the best effect. It may require airbrushing to blend adjacent areas together, or even painting in new elements (for example, painting additional blades of grass to overlap the character art). It could also involve cutting and pasting elements from several different photos to piece together into a unique background that suits the needs of the picture. For example, taking photos of trees around the neighbourhood, and then editing out any sign of civilization to make a forest scene.

You can save yourself some time by remembering that the portion of the background covered by the character art can be left untouched and incomplete, as it won't be seen in the final image.

LIGHTING

The lighting on the character should be consistent with the lighting in the photo. If the light source in the photographic background is coming from the right side of the image, the shadows should be on the left-hand side of objects, including the left-hand side of the character.

ILLUSION OF DEPTH

The human eye cannot focus on more then one area at a time. If you look closely at a person, other objects in your view will be out of focus. Alternatively,

focus on an object behind the person, and the person will be out of focus. For a realistic effect, imitate this characteristic by blurring or decreasing the detail in the background. The blurry background will trick your eye into focusing on the character.

COPYRIGHT

Be aware of copyright when using photographs in your images. Unless you have permission from the photographer, it's not a good idea to simply take a photo off a website or scan it out of a magazine. To be on the safe side, always stick to photos that you either took yourself or have permission to use. This also ensures that you'll be working with higher-quality images, since you're using your own resources rather than using small images of dubious quality off websites.

▶ The forest background was originally a photo reference shot. In Photoshop, using the Rubber Stamp tool, the background was carefully reformed around the character. In order to achieve a more natural fusion of character art and background, the photo element was then moved into Painter for reworking. There, a substantial amount of over-painting and additions were made to the trees and foliage. Finally, the background was reopened in Photoshop for dodging and lighting effects.

▼ This image makes use of two photographs: the first, a delicious close-up of a cluster of strawberries, carefully cropped, airbrushed, and blurred for integration with the character art; and the second, a close-up of celery.

GRAPHIC DESIGN BACKGROUNDS

A background need not always be a painted scene. There are a number of graphic design elements such as flat colour, gradient, pattern, texture, and text that can be employed in manga-style images to fill negative space and accentuate the character art. When used appropriately, graphic design backgrounds can yield satisfactory results.

FLAT COLOUR

Flat-colour backgrounds are simple to do: just fill the bottom layer with the colour of your choice (preferably one that complements or contrasts with your image in a pleasing manner), and you're done. While it works in some circumstances, by itself a flat-colour background generally tends to be static and boring. For added visual interest, try arranging multiple flat colours into an interesting design.

GRADIENT

Like the flat-colour background, the gradient background is easy to do. Use the Gradient tool in conjunction with your desired colours on the bottom layer. The effect can be good for setting a mood. Don't go overboard by using every colour of the rainbow in your gradient. Stick to a few colours that complement the character art. Misuse can make the picture look cheap. Also try combining the gradient with textures or patterns.

CASUAL

▲ In this image, the primary focus is on the character design. The background needed to be fairly clean and simple. I left the background as a flat colour with a smidgen of design elements, including strings of dots (for added texture), and juxtaposed photographs of clothing and descriptive text to round off the picture.

◄ As the girl cries over a spilled drink, the flat colour, jagged-edged background, and bold text emphasize her horror. The illustration conveys the message and emotion through the use of a simple background.

PATTERNS AND TEXTURES

A patterned background fills empty space while adding texture, thereby helping to counteract the monotony of a plain, white background in an image. Keep an eye out for interesting patterns wherever you go, and keep an easy-to-browse selection on file so that you have them to hand when you need them. Patterns can be found in a variety of places. They can come from fabrics, books, photographs, catalogues, etc. You can purchase patterned paper (normally intended for scrapbook projects) from art shops, and screentone from shops specializing in Japanese manga supplies. With a digital camera, texture can even come from nature – you never know when leaf patterns and sand-gravel might come in handy!

TEXT

Text can be an effective way of incorporating information into the design of an image. The text can take the place of the background and can be used for either an aesthetic or an informative purpose. Text can also be used as a way of protecting your images on the Web: adding the URL to your website, or your name and email address can be an effective way of identifying yourself as the rightful owner of the image. Use the Type tool found on the Photoshop Tools palette to apply text to your images.

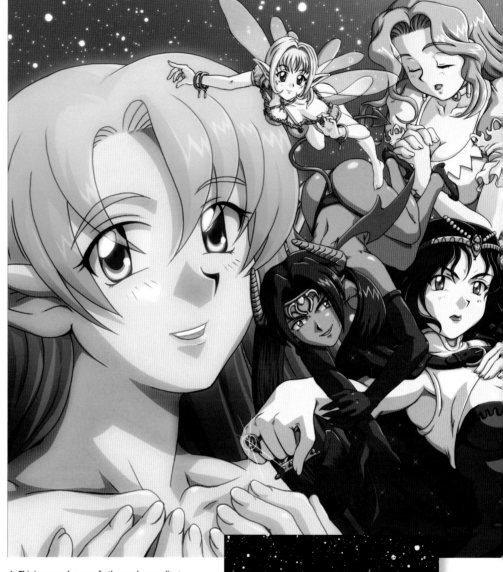

▲ **This image makes use of a three-colour gradient combined with an image of speckled white dots on a black background set to Layer Blending Mode> Color Dodge.**

12

ADVANCED TECHNIQUES: FINISHING TOUCHES AND SPECIAL EFFECTS

Congratulations! You've reached the final chapter of the book, which means one of two things: either you're skipping around for a casual read-through, or you've worked through all the previous chapters. If you fall into the latter category, chances are that you now have a drawing that has been scanned, inked, or retouched, digitally coloured, and given a background. While you could call it finished at this point, there are a number of advanced techniques you can still apply to your image to make it really shine.

That's what this chapter is all about: it covers a variety of finishing touches and special effects, ranging from coloured lines, layers styles, and blending modes, lighting and colour effects, patterns and textures, to the ever-popular Photoshop filters. Plus, not only will you learn how to use them, but also when each of these effects and filters has a practical use.

When working with the advanced techniques, caution is advised. There are more wrong ways than right ways to use them. Filters have a bad reputation for overuse, and for good reason. When used carefully, filters and effects enhance an image, but when used recklessly, they can do the opposite. Only use the techniques needed to accomplish your vision. As always, have fun with it and experiment, but take care not to go overboard!

COLOURED LINES

There are many reasons for using coloured lines, including softening and shifting focus, emphasizing mood, illustrating special effects such as sweat, water droplets, and magical spells, and adding texture to fabrics and metals. This section discusses how to change the colour of your line art to achieve various image effects.

Changing the colour of the line art is an intermediate-level technique that helps soften the lines, taking the focus off the line art and on to the colouring. Artists use this technique selectively on the image rather than uniformly – for example, only colouring the outline on a certain area, such as the hair or an outfit.

CHANGING THE BLACK LINE ART TO A DIFFERENT SINGLE COLOUR

The basic technique involves changing the line art to a colour besides black, in effect softening the image and potentially emphasizing mood.

INKING

If you're digitally inking your image, you can save yourself some time by inking the image in the colour of your choice. As there are other methods of producing coloured lines, it is also fine to wait until after the image is inked.

HUE/SATURATION

In Photoshop, while on the line art layer, choose Image>Adjust>Hue/Saturation to bring up the Hue/Saturation menu. First, check the Colorize box. Then slide the Hue bar and the other two bars back and forth until the lines become your desired colour. Hue changes the colour, Saturation changes the colour intensity, and Lightness controls how light or dark the colour is. Be sure to move the Lightness slider above 0, or the lines will remain black.

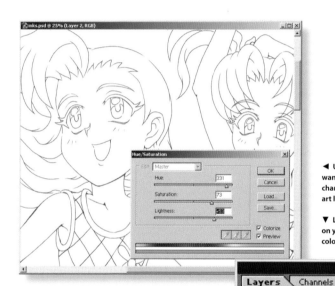

◄ Use Hue/Saturation if you want to make a uniform colour change for the entire line art layer.

▼ Lock the transparency on your line art to prevent colouring outside the lines.

CHANGING THE BLACK LINE ART INTO MULTIPLE COLORS

Changing the line art into multiple colours (for example, dark brown lines for skin, dark yellow lines for blonde hair), is a more involved process, but not really complicated. For this method to work, your line art must be on a transparent layer. In Photoshop, set your line art layer to Preserve Transparency to prevent colouring outside the lines.

▶ Choose a colour (generally a darker version of the object's colour), and use the Brush tool to paint over the black line art to change the colour. It's especially useful for clothing to help give it a more realistic, softer look.

▲ Left: The fireball on the red shirt has a darker red outline, making it look as though it's been stitched into the fabric. Right: Lighter colours were used for the design on the blonde character's pink shirt.

▲ The stripes, flower, and yellow trim on the middle girl's dress were changed to a dark blue, dark orange, and dark yellow respectively.

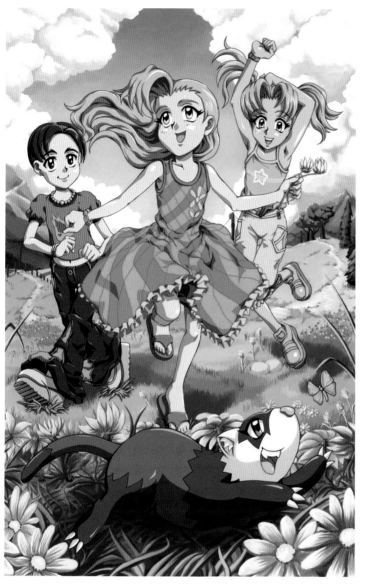

▲ This image uses coloured lines to soften details of the girls' clothing.

▲ This image uses coloured lines for special effects. Note the solitary strands of hair catching the last glint of light from the setting sun, and the transparent blue-lined tears streaking down the girl's face.

LAYER STYLES AND BLENDING MODES

In addition to the practical usage of layers for organizing portions of an image for editing, layers can also be used to achieve a variety of advanced techniques. Photoshop special effects such as glowing edges and drop shadows can be created with layer blending options.

LAYER BLENDING OPTIONS

Layer blending options only affect an individual layer, so your image may require some preparation beforehand. If the portion of the artwork you wish to modify is comprised of several layers, you'll first need to merge the layers together. Make all the layers you wish to merge visible, and then choose Edit>Copy Merged. Paste and align this merged layer beneath the other layers, and apply all layer effects to this new layer.

To use Layer Effects, right-click on the title of the layer you wish to apply effects to, and choose Blending Options. This opens the Layer Style menu, containing a long list of effects. Two of the more useful effects, in terms of character artwork, are Drop Shadow and Outer Glow, but don't be afraid to experiment with the full range of effects for interesting results.

DROP SHADOW

Drop Shadow is a simple effect that creates an added sense of dimension to relatively flat, two-dimensional artwork. When applied, it constructs a shadow in the shape of the layer selected just slightly beneath the original. Drop Shadow works best on light-coloured backgrounds.

Within the Drop Shadow interface, different shadow colours can be selected, an angle dial can be used to specify the direction of light and shadow, and sliders can be set for variables like shadow distance, size, spread, and shadow opacity.

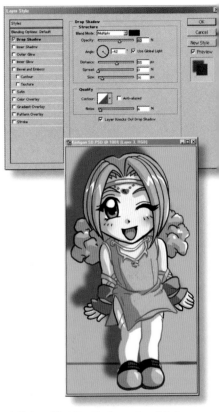

▲ The Layer Effects Drop Shadow creates a distinct shadow area behind the character artwork.

◄ Creating a new layer with the Layer Effect allows you to work on it like a normal layer.

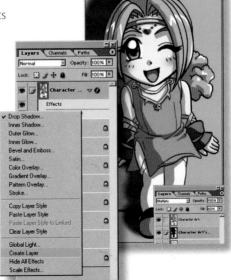

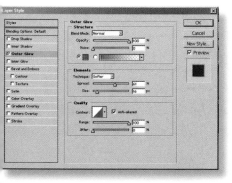

STROKE

The Stroke (an effect similar to Outer Glow) and Color Overlay Layer Effects were used to create a thick outline around the 'Electromagic' droplets discharging off the boy's digital cel art. First, the blue-coloured droplets were drawn with the Brush tool. Then Stroke and Color Overlay effects were applied to change the colour of the droplets to white and the outline to blue.

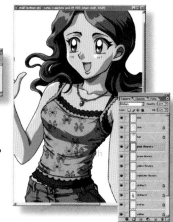

▲ ▶ To help spruce up the girl's plain, green shirt, four different flower patterns are drawn, copied, and pasted into multiple layers set to Multiply above the shirt layer. Any elements that fall outside the edge of the shirt are carefully erased.

LAYER BLENDING MODES

Layer blending modes can be used to blend multiple layers together for varying effects. Keep in mind that blending modes work downwards: the layer with the blending mode applied affects all layers beneath it. Blending modes such as Multiply and Overlay can be used to apply textures and patterns on top of character art for added visual interest.

▲ **The Outer Glow Layer Effect adds a coloured edge around the character.**

OUTER GLOW

Outer Glow is often employed as a division, separating character artwork from the background and other image elements. It can also be used to create a magical glow, aura, or light around the character. It creates a specifically denoted glowing edge around a section of pixels. Through use of the sliders, the size, spread, opacity, and noise can be modified, as well as the colour and blending method. It's a good technique for character-centric artwork, but erodes any semblance of setting in a picture, leaving the character on one plane and the background on another. Outer Glow works best when set against dark backgrounds.

OPACITY PERCENTAGE

A layer can be made transparent by modifying the opacity percentage on the Layers palette.

◀ **For a convincing result, it's important to plan transparency from the beginning. Knowing that the coffee pot would be transparent, underlying objects were drawn and coloured as though the pot wasn't there. Then the coffee pot was coloured to give the glass substance. Finally, to allow the objects to show through, the opacity was lowered to 70%. The Airbrush tool already gives some degree of transparency, but the same effect could have been achieved with a solid colour and a lower opacity setting.**

LIGHTING AND COLOUR EFFECTS

Lighting and colour effects might be just what your manga-style illustration needs to give it that finished polish. Lighting effects are useful for achieving all sorts of special effects, from beams of sunlight to glowing magic wands, regardless of whether your image is an everyday scene or one of the more fantastic or supernatural varieties.

This section shows you how to use a combination of layer composition methods, gradients, dodges, and burns to create extensive lighting and colour effects.

DODGES AND BURNS

Traditionally used by photographers to adjust the tones in their photographs, the Dodge and Burn tools are also capable of producing stunning results in artwork. The Dodge tool can be used to accentuate highlights, such as the shine in the characters' eyes, metallic objects, and vinyl. The Burn tool can darken and intensify shadows.

Despite this, dodges and burns both have a poor reputation in digital manga art largely due to misuse. A beginner's mistake is to rely upon the tool to do all of the shading, leading to a picture where all the shadow and highlight colours are predetermined by the nature of the tools. For best results, the key is to stick to using the tool only where most effective, rather than using it as the sole tool for colouring.

In the image featured in this section, dodges are applied to the main character's cheeks, eyes, and hair highlights, the edge of the businesswoman's jacket, the man's suit, the black-haired girl's vinyl skirt, shoes, and backpack, and the blonde girl's metal wand and bracelet. The Burn tool was used more sparingly to deepen the colours in the main character's eyes, and to accentuate the metallic objects. The overall effect is to add shine and glitter – something special – to the image.

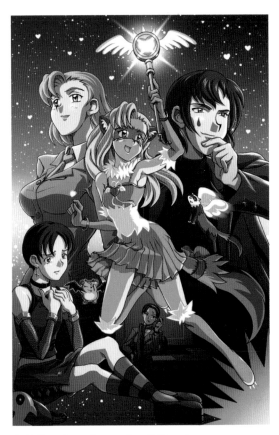

▲ **This illustration employs a number of lighting color effects, including dodges, burns, and gradients.**

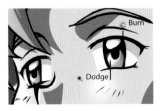

▲ What the layer actually looks like on Normal.

▲ The layer set to Color Dodge.

COLOR DODGE LAYERS

Dodges can be applied in a number of ways. They can either be applied directly on to the colouring using the Burn and Dodge tools, or by using Color Dodge layers. This involves a slightly different technique that yields the same result without affecting the underlying art. Make a new layer, and fill it with black. Next, set the layer blending mode to Color Dodge. Using standard brush tools, you can now add dodges to your image that can be easily turned off by hiding the layer, allowing for experimentation.

GRADIENTS

Gradients are wonderful for producing a smooth shift from one colour to another. They can be used to add some extra colour and visual interest to an image, or to fade an element into the background. This is especially useful when working with cel-coloured images, allowing you to add some gradation between colours while retaining the sharp divisions between them.

A white-to-magenta gradient has been applied to the man in this picture to make him subtly fade into the dark purple background. The gradient was done by making a copy of the layer containing the character's colours, locking Preserve Transparency, filling the new layer with white, and then filling the layer with a linear gradient set from white to magenta. To blend the gradient into the picture, the layer was then set to Multiply. The woman in the business suit received similar treatment.

▲ The layer set to Multiply.

PHOTOSHOP FILTERS AND EFFECTS

Photoshop contains a large number of built-in filters that perform a variety of image effects. You aren't limited to the basic set that Photoshop provides, either. You can purchase other filters at stores or download them from the Web as shareware or freeware.

Photoshop's filters are actually sub-programs or macros that modify your existing image data and/or insert new elements into your image or selection. These filters can be found on the Filters menu, sorted under numerous sub-menus, such as Artistic, Blur, Noise, Render, Texture, Other, Sketch, etc.

TYPES OF FILTERS

There are filters that render objects such as the moon and earth, filters that change white portions of your image into transparent areas, filters that apply an assortment of textures, and even filters that add flames, water bubbles, and patterns.

When using filters, keep several things in mind:

- There is more to digital artwork than simply running a Photoshop filter over a scanned image! No filter will finish your image or fix any problems with the drawing and colouring.
- Don't overuse them! Filters and effects can enhance your image if you use them with caution, but they won't make a poorly executed picture look better. If a filter doesn't add anything to the image, don't use it.
- Don't be afraid to experiment. The best way to work out which filters are useful and which aren't is to play around with them and see what they do.

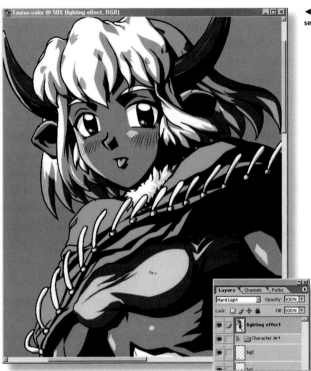

◄ The layer blending mode is set to Hard Light.

BLUR

The Blur filters, found on the Filters menu, have many practical purposes. Blurring the background of your image can help separate the character art from the background art, creating an optical illusion of depth in a two-dimensional image. It can also help smooth out sharp picture elements that might otherwise be too jarring. Blur filters can also be used in combination with other techniques to soften images without obscuring the details they contain.

Photoshop provides six different Blur options. The first two, Blur and Blur More, create subtle blur effects. They don't substantially blur anything unless you run them several times. The third Blur option, Gaussian Blur, uses a slider to control the amount of blur effect applied to an image. Motion Blur can be used to make an object look like it is in motion. The final two, Radial Blur and Smart Blur, are more specialized effects that can only be used in certain situations.

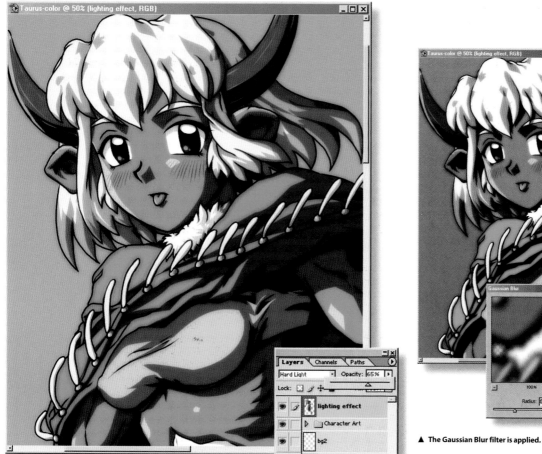

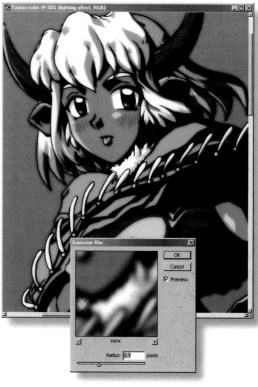

▲ The Gaussian Blur filter is applied.

◀ The opacity is reduced to 65%.

SOFTENING AND SATURATION

This technique moderately blurs the image and saturates the colours, illuminating everything in the affected area. Make the layers you wish to soften and saturate visible, and turn off all other layers. Choose Select>Select All, and then choose Edit>Copy Merged. Paste this new layer over the other layers, and align it so it overlaps the original artwork. Set the layer blending mode to Hard Light. Run the Gaussian Blur filter on the layer with a radius of 6.0 pixels. To lower the intensity of the effect, drop the opacity percentage to 65–75%.

OTHER FILTERS

- The Displace filter (Filter>Distort> Displace) is a complicated and time-consuming filter good for stretching repeating patterns around the contours of an object
- The Clouds filter (Filter>Render> Clouds) adds a hazy, cloudlike pattern into your image

- The Watercolor filter (Filter> Artistic>Watercolor) can modify your image so that it looks like it was painted with a real watercolour brush
- The Texturizer filter (Filter> Texture>Texturizer) can be used to apply burlap, canvas, brick, or other texture to an area of your image

13

APPENDIX

In this final, short section, you will find a keyboard shortcut table, which we hope you
will find very useful. Perhaps you will already have some familiarity with these, but if you
don't, it's worth spending some time doing just that – it really does help you to work more
efficiently on your manga-style characters if you have the functions ready at your fingertips.
In addition to the shortcuts feature, we include an easy-reference glossary of many of the
terms we use throughout the book. Some of the jargon may be new to you, but before long
you will be up to speed with the digital manga-speak.

SHORTCUT KEYS

Using your hands in tandem, one on the stylus, and one on the keyboard, makes many tasks in digital artwork flow much smoother. Many times, a click of a single key can save you from having to stop what you're doing to search for a tool or command within an application.

The most recent versions of both Photoshop (CS) and Painter (IX) allow for almost total customization of shortcut keys. Even so, the default shortcut key layouts in both applications are logically placed and mostly interchangeable between applications, making it well worth sticking with.

In the list below, shortcut keys most often used for manga-style artwork are highlighted.

PHOTOSHOP

File menu

Action	Shortcut Command
New	Ctrl+N
Open	Ctrl+O
Close	Ctrl+W
Save	Ctrl+S
Save As	Shift+Ctrl+S
Save for Web	Alt+Shift+Ctrl+S
Print	Ctrl+P
Exit (Quit)	Ctrl+Q

Edit menu

Action	Shortcut Command
Undo/Redo*	Ctrl+Z/ Ctrl+Y*
Back/Forward in History	Ctrl+Alt+Z
Cut	Ctrl+X
Copy	Ctrl+C
Copy Merged	Shift+Ctrl+C
Paste	Ctrl+V
Paste Into	Shift+Ctrl+V
Free Transform	Ctrl+T

Image menu

Action	Shortcut Command
Levels	Ctrl+L
Auto Levels	Shift+Ctrl+L
Auto Contrast	Alt+Shift+Ctrl+L
Auto Color	Shift+Ctrl+B
Curves	Ctrl+M
Color Balance	Ctrl+B
Hue/Saturation	Ctrl+U
Desaturate	Ctrl+Shift+U
Invert	Ctrl+I

Layer menu

Action	Shortcut Command
New Layer	Shift+Ctrl+N
Layer Via Copy	Ctrl+J
Layer Via Cut	Shift+Ctrl+J
Group With Previous	Ctrl+G
Ungroup	Ctrl+Shift+G
Bring to Front	Shift+Ctrl+]
Bring Forward	Ctrl+]
Send Backward	Ctrl+[
Send to Back	Shift+Ctrl+[
Merge Down	Ctrl+E
Merge Visible	Ctrl+Shift+E

Select menu

Action	Shortcut Command
Select All	Ctrl+A
Deselect	Ctrl+D
Reselect	Ctrl+Shift+D
Inverse	Shift+Ctrl+I
Feather	Alt+Ctrl+D

Tools

Action	Shortcut Command
Rectangular Marquee	M
Lasso	L
Healing Brush	J
Clone Stamp	S
Eraser	E
Blur	R
Pen	P
Notes	N
Type	T
Eyedropper	I
Shape	U
Slices	K
Hand	H
Move	V
Magic Wand	W
Paintbrush	B
History Brush	Y
Dodge/Burn	O
Gradient	G
Zoom	Z

Miscellaneous

Action	Shortcut Command
Move Image (Hand Tool)	Hold Space
Move Tool	Hold Ctrl
Eyedropper Tool	Hold Alt (while paintbrush is selected)
Fill with Foreground Color	Alt+Backspace
Fill with Background Color	Ctrl+Backspace
Swap Foreground and Background Colors	X
Zoom In	Hold Space+CTRL+Click
Zoom Out	Hold Space+Alt+Click
Increase Brush Size	Press the] key
Decrease Brush Size	Press the [key

*Depending on setting in Photoshop's General Preferences. We prefer setting Undo to CRTL+Z and Redo to CTRL+Y.

PAINTER
File menu

Action	Shortcut Command
New	Ctrl+N
Open	Ctrl+O
Close	Ctrl+W
Save	Ctrl+S
Print	Ctrl+P
Exit (Quit)	Ctrl+Q

Edit menu

Action	Shortcut Command
Undo	Ctrl+Z
Redo	Ctrl+Y
Cut	Ctrl+X
Copy	Ctrl+C
Paste	Ctrl+V

Effects and Select

Action	Shortcut Command
Fill	Ctrl+F
Select All	Ctrl+A
Deselect	Ctrl+D
Reselect	Ctrl+R

Brushes

Action	Shortcut Command
Increase Brush Size	Press the] key
Decrease Brush Size	Press the [key
Resize Brush (Click and drag stylus to increase or decrease size)	Alt+Ctrl or Shift+Alt+Ctrl in some versions

Tools

Action	Shortcut Command
Magnifier	M
Grabber	G
Crop	C
Lasso	L
Magic Wand	W
Pen	P
Rectangular/ Circular Shape	I / J
Brush	B
Paint Bucket	K
Dropper	D
Rectangular/ Circular Selection	R / O
Shape Selection	H
Rotate Page	E
Text	T

Miscellaneous

Action	Shortcut Command
Show/Hide Palettes	Tab Key
Center Image	Spacebar+Click
Zoom In	Spacebar+ Ctrl+Click
Zoom Out	Alt+Ctrl+Click
Toggle Straight Line/Freehand Strokes	V/B
Show/Hide Palettes	Ctrl+Numbers 1-9
Move Image (Hand Tool)	Hold Spacebar
Rotate Image	Hold Alt+Spacebar
Return Rotated Image to Original State	Alt+Spacebar+Click
Adjust Opacity	Numbers 1 through 0
Color Talk	N

GLOSSARY

Adobe Photoshop
A computer graphics application that was originally designed for photo-editing and image composition. It's well suited for digital manga-style artwork, and is considered the most comprehensive of all graphics software.

alpha channel
A special type of layer (actually, an 8-bit colour channel) used in graphics applications for saving, manipulating, and retrieving selection and masking information.

anime
The Japanese word for any type of animation. English-speakers use the word to specifically describe Japanese animation.

anime style
Used interchangeably with 'manga style' to describe the distinct, but differing styles of artwork styles found in Japanese animation. Anime-style artwork is best known for, but not limited to, its emphasis on big eyes, small mouths, and rainbow-coloured hair. It can also be used to describe cel-style artwork.

anti-aliasing
A method of blending in computer graphics between differing pixel information to create the realistic visual illusion of smooth gradual shading.

BMP
Bitmap File Format.

CD-R
Compact Disc Recordable. Writeable, removable storage medium excellent for backing up finalized image data.

cel (or cell)
Short for celluloid acetate, a type of transparent film used in animation.

cel style
A distinct colouring style that uses multiple flat tones of colour to show depth in an illustration.

CG/CGI
Computer Graphics/Computer Generated Imagery. CG and CGI are terms that cover any computer. A scratchy image put together in Windows Paint, a manipulated photo in Photoshop, and a three-dimensional, computer generated element are all examples of CG.

CGing/CGed
The act of creating computer graphics (in the present and past tense).

Corel Painter
A computer graphics application that contains digital tools that simulate traditional art tools. It can perform sketching, inking, and painting – perfect for digital manga artwork.

CRT
Cathode-Ray Tube. Primary component of a standard monitor. The abbreviation is often used to differentiate between standard monitors and LCDs.

DPI
Dots per inch. Measures resolution, and determines the detail and clarity of a scanned or printed image.

DVD-R
Digital Versatile Disc Recordable. Writeable, removable storage medium excellent for backing up large amounts of finalized image data.

GB
Gigabyte. Standard unit of size for digital information. One gigabyte equals 1024 megabytes. Often 5 to 10-plus complete manga images, including working files, saved reference, and alternate versions occupy about a GB in storage space.

GIF
The Graphic Interchange Format.

jagged or jaggies
Refers to the distinctly sharp visual appearance of unblended edge pixels in digital imagery. Anti-aliasing techniques are often employed by default in graphics applications to minimize the unsightly jagged edges digital creation/manipulation would otherwise produce in images.

JPEG/JPG
Image file format designed by the Joint Photographic Expert Group.

LCD
Liquid-Crystal Display. More recent advance in display technology.

LZW
A form of lossless compression incorporated into the saving schemes of several different file formats.

manga
The Japanese term for comics. English-speakers use the word to describe Japanese comics.

manga style
Used to describe the different styles of Japanese comic artwork. Since manga is generally black and white, the word manga is most commonly associated with black-and-white works only, especially comics, but can be expanded to refer to any sort of anime-style illustration of the non-animated variety.

MB
Megabyte. Standard unit of size for digital information. 1/1024th of a Gigabyte. The text of a small book requires about one megabyte of storage space. Many work-in-progress digital manga images range from 15 to 200MB in size, depending on the image size and the extent of layers in the file.

OCR
Optical Character Recognition. A process involving scanning software and hardware to recognize and convert scanned in printed or handwritten material to its digital keystroke equivalent.

pixels
Dots of light that are displayed by a monitor. All images displayed on a screen are made out of pixels.

PPI
Points or Pixels per inch. *See DPI.*

PSD
Photoshop File Format.

RAM
Random Access Memory. A memory chip where non-permanent information is loaded and then utilized. Data files are loaded off the relatively slow hard drive, and placed in memory (RAM) where the computer can access the information quickly. The more RAM installed on your computer, the easier it is to work effectively with large files. RAM storage capacity is usually denoted in MB.

resolution
The amount of pixels present in an image. A small image may only be 300 x 200 pixels. This would be considered low-resolution. A high-resolution picture could be 1024 x 768 pixels, or larger. The higher the resolution, the larger and more detailed the picture.

Riff/RIF
The Raster Image File Format.

screen resolution
The amount of pixels that your monitor (and graphics card) is capable of displaying at one time. Common screen resolutions are: 640 x 480, 800 x 600, 1024 x 768, 1152 x 864, and 1280 x 1024.

spotting blacks
A technique in which a penciller indicates (usually with a simple mark) an area requiring filling in with black later in the inking process. Often this technique is used to dramatically pop out, or draw attention away from, areas within an image. This term can also be used to indicate a heavy usage of blacks within a digital image (spotted blacks).

stippling
A technique often used in inking that involves using repeated dots of various size and density to create the illusion of shadows and textures.

stylus
A pressure-sensitive pen used in conjunction with a digital graphics tablet to draw and paint directly on to the computer.

super deformed (SD)
Term primarily used to describe a style found in manga and anime which involves shrinking a character down to exaggerated proportions, generally in the range of three heads tall.

tablet
The digital graphics tablet is used in conjunction with a pressure-sensitive pen to draw and paint directly onto the computer, and is a must for the serious digital artist.

Tif/TIF
Tagged Image File Format.

working file
A work-in-progress file. This can be either a full-sized, possibly multi-layered final copy of an image, or an earlier file saved while working toward a finished image. Either way, it denotes an image of full integrity that is not harmfully finalized by compression, resizing, or flattening of image layers.

FURTHER RESOURCES

BOOKS

Traditional Drawing / Inking / Painting Resources

Agnew, John, *Painting the Secret World of Nature*, North Light Books, 1507 Dana Avenue, Cincinnati, Ohio 45207, 2001

Complete Guide to Drawing & Painting, Reader's Digest, 1997

Hamm, Jack, *Drawing Scenery: Landscapes and Seascapes*, The Berkeley Publishing Group, 375 Hudson Street, New York, NY 10014, 1988

K's Art, *How to Draw Manga: Putting Things in Perspective*, Graphic-sha Publishing Co., Ltd., 1-14-17 Kudan-kita, Chiyoda-ku, Tokyo 102-0073 Japan, 2004

Martin, Gary, *The Art of Comic Book Inking*, Dark Horse Comics, Inc, 10956 SE Main Street, Milwaukie, OR 97222, 1997

Ross, Bob, *More Joy of Painting*, Quill, 1350 Ave of the Americas, New York, NY 10019, 1991

The Society for Study of Manga Techniques, *How to Draw Manga (Volume 2) Compiling Techniques*, Graphic-sha Publishing Co., Ltd., 1-14-17 Kudan-kita, Chiyoda-ku, Tokyo 102-0073 Japan, 2001

Character Creation and Design Resources

Aoki, Shoichi, *Fruits*, Phaidon Press Inc., 180 Varick Street, New York, NY 10014, 2004

Go Office, *More How to Draw Manga (Volume 2) Penning Characters*, Graphic-sha Publishing Co., Ltd., 1-14-17 Kudan-kita, Chiyoda-ku, Tokyo 102-0073 Japan, 2004

Gorsline, Douglas, *What People Wore:1800 Illustrations from Ancient Times to the Early 20th Century*, Dover Publications, Inc., 31 East 2nd Street, Mineola, N.Y. 11501, 1994

Colour Resources

Cabarga, Leslie, *The Designer's Guide to Color Combinations*, North Light Books, 1507 Dana Avenue, Cincinnati, Ohio 45207, 1999

Cabarga, Leslie, *The Designer's Guide to Global Color Combinations*, North Light Books, 1507 Dana Avenue, Cincinnati, Ohio 45207, 2001

Collections of Art

Sugiyawa, Rika, *Comic Artists – Asia: Manga Manhwa Manhua*, Harper Design International, 10 East 53rd Street, New York, NY 10022, 2004

Sugiyawa, Rika, *Japanese Comickers: Draw Anime and Manga like Japan's Hottest Artists*, Harper Design International, 10 East 53rd Street, New York, NY 10022, 2004

HARDWARE RESOURCES

Wacom Technology Corporation
1311 SE Cardinal Cour
Vancouver, WA 986683
USA
http://www.wacom.com/

SOFTWARE RESOURCES

Adobe Systems Inc.
345 Park Avenue
San Jose, CA 95110-2704
USA
http://www.adobe.com/

Corel Corporation
1600 Carling Avenue
Ottawa, Ontario
Canada
K1Z 8R7
http://www.corel.com/

ART SUPPLIES

Online retail stores for traditional manga supplies, including pens, paper, and screen tone, as well as art books, manga, DVDs, and other anime- and manga-related merchandise.

Akadot Retail
1123 Dominguez St., Suite L,
Carson, CA 90746
00 1 (310) 604 7566 /(Fax) 00 1 (310) 604 1134
http://www.akadotretail.com/

AnimeBooks.com
P.O. Box 14247
Irvine, CA 92623-4247
http://www.animebooks.com/

AnimeNation
13929 Lynmar Boulevard,
Tampa, Florida 33626
00 1 (813) 925-1116
http://www.animenation.com/

Japanime Co. Ltd.
2-8-102 Naka-cho
Kawaguchi-shi, Saitama 332-0022
Japan
http://www.howtodrawmanga.com/

ONLINE SHOPS FOR TRADITIONAL ART SUPPLIES

Dick Blick Art Materials
P.O. Box 1267
Galesburg, IL 61402-1267
http://www.dickblick.com/

Pearl Art & Craft Supply
1033 E. Oakland Park Blvd.
Ft Lauderdale, FL 33334
http://www.pearlpaint.com/

Blue Line Pro
166 Mt. Zion Road,
Florence KY 41042
00 1 (859) 282-0096
http://bluelinepro.com/

MisterArt.com
00 1 (866) 672 7811
http://www.misterart.com

Cheap Joe's Art Stuff
374 Industrial Park Drive
Boone, NC 28607
00 1 (800) 227 2788
http://www.cheapjoes.com

INSPIRING ARTISTS

Akihiko, Yoshida
Illustrator
Tactics Ogre, Vagrant Story, Final Fantasy Tactics

Clamp
Manga Artists
Magic Knight Rayearth, Card Captor Sakura, Chobits

Gainax
Animation Production studio
Neon Genesis Evangelion, Wings of the Honeamise

Harada, Takehito
Illustrator
Disgaea, Phantom Brave

Hasegawa, Shinya
Character Designer, Animation Director
Utena, Neon Genesis Evangelion

Ikeda, Riyoko
Manga Artist
Rose of Versailles

Ishida, Atsuko
Character Designer, Manga Artist
Magic Knight Rayearth, Shamanic Princess

Ishikawa, Fumi
Character Designer
Suikoden II, III, Fire Emblem

Ito, Ikuko
Animation Director, Character Designer
Magic User's Club, Princess Tutu

Itoh, Ryoma
Character Designer
Final Fantasy Tactics Advance

Kameoka, Shinichi
Character Designer
Legend of Mana

Kawamoto, Toshihiro
Animation Director, Character Designer
Wolf's Rain, Cowboy Bebop

Kishiro, Yukito
Manga Artist
Battle Angel Alita, Aqua Knight

Kon, Satoshi
Animation Director
Perfect Blue, Millenium Actress

Masamune, Shirow
Manga Artist, Illustrator
Ghost in the Shell

Miyazaki, Hayao
Manga Artist, Animation Director
Spirited Away, Nausicaä

Mucha, Alphonse
Artist
Exponent of the Art Nouveau Movement

Murata, Range
Illustrator, Character Designer
Last Exile

Nakajima, Atsuko
Character Designer
Ranma ½

Nanase, Aoi
Character Designer, Manga Artist
Angel Dust, Seraphim Call

Nishimura, Kinu
Illustrator, Character Designer
Street Fighter

Oh! Great
Manga Artist
Tenjo Tenge, Himiko-den

Sadamoto, Yoshiyuki
Illustrator, Manga Artist, Character Designer
Neon Genesis Evangelion

Sato, Junichi
Anime Producer / Director
Sailor Moon, Princess Tutu

Takeuchi, Naoko
Manga Artist
Sailor Moon

Urushihara, Satoshi
Illustrator, Manga Artist, Character Designer
Plastic Little

Watase, Yuu
Manga Artist
Fushigi Yugi, Ceres

Yamada, Akihiro
Illustrator, Manga Artist, Character Designer
Record of Lodoss War, The Twelve Kingdoms

Yuuki, Nobuteru
Character Designer, Illustrator
Record of Lodoss War, Escaflowne

WEB RESOURCES

Artist Communities and Directories

Online Comic Artist Directory
http://ocad.syste.ms/

The Art Corner
http://www.artcorner.org/

CGTalk
http://www.cgtalk.com/

Conceptart.org
http://www.conceptart.org/

GFXartist
http://www.gfxartist.com/

CGChat.com
http://www.cgchat.com/

Epilogue
http://www.epilogue.net/

Reference Materials

Morgue File
http://www.morguefile.com/

ArtMorgue.com
http://www.artmorgue.com/

Human Anatomy Pictures
http://www.fineart.sk/

INDEX

ACKNOWLEDGMENTS

Digital Manga Workshop is the culmination of around six years' work focused on understanding the artistic techniques common to the production of manga-style artwork. In effect, it's the dissemination of what we have learned and experienced as manga-style artists, and translated in order to instruct others on precisely how we do what we do. By putting together this book, we hope to add to the growing knowledge base of manga-style art technique in the West.

In part, this book is a distillation of the mostly technical knowledge gained from our experience and our observation of other inspirational artists. We owe them for pioneering the path that we follow. To those artists – too numerous to mention – we offer our thanks. Their efforts have inspired us to improve with every picture we make.

During the last months of production, quite a few small projects were put aside in order to focus on the book. With that in mind, thank you to our many patrons who continue to support our artistic endeavours. It's because of you that much of the artwork in this book exists. You kept us alive at the beginning of our career and help us thrive in the present. We hope you will forgive us for our relative absence from the Web, and stick with us as our art evolves into the realm of publishing.

We offer a heartfelt thanks to the staff at Ilex Press, including all of the editors who we've been in contact with throughout the process of conception and creation of this book, and especially Kylie Johnston who was with us during the longest stretch of the production. Thank you to the designers who have created this final product. So, to all at Ilex, thank you for this opportunity and the patience you've shown over scheduling and other concerns.

On the topic of patience, we must also thank our editor, Jodi Bryson, and the managing staff at TOKYOPOP for granting us an extended break between volumes of our graphic novel, *Peach Fuzz*, so that we could pursue this project. Hopefully, the fans will forgive us for the wait between volumes.

As our lives have become more and more hectic over the last several years, we've often asked much of our families in terms of patience and understanding. Often circumstances have required that they reschedule their lives around our chaotic, seemingly unending work schedule. Thanks to our families for their love and understanding during these interesting times.

And, most importantly, thanks to all the readers for picking up this book!